BASEBALL
IN ROCKFORD

For Sara, a true
baseball fan. Enjoy
Baseball in Rockford.

Ken Griswold

BASEBALL
IN ROCKFORD

Dr. Ken Griswold

ARCADIA

Published by Arcadia Publishing,
an imprint of Tempus Publishing, Inc.
Charleston SC, Chicago, Portsmouth NH,
San Francisco

Printed in Great Britain.

Library of Congress Catalog Card Number: 2003108758.

For all general information contact Arcadia Publishing at:
Telephone 843-853-2070
Fax 843-853-0044
E-Mail sales@arcadiapublishing.com
For customer service and orders:
Toll-Free 1-888-313-2665

Visit us on the internet at http://www.arcadiapublishing.com

This book is dedicated to my wife Robin, who helped me in so many areas, including sharing her refined PC skills and digital camera expertise with me. Most important, however, was her continued encouragement, at all times, throughout the writing.

CONTENTS

ACKNOWLEDGMENTS

THE AUTHOR WOULD LIKE to thank the following individuals for their assistance in preparing this book for publication:

Nellene Jeter, Chairman of the A.G. Spalding Commission and Penny O'Rourke, Library Director, who both made available to me the collection of pictures and artifacts that are housed in the Byron Public Library.

David Byrnes, President and CEO of the Rockford Midway Village and Museum Center provided the assistance of his staff, especially David Oberg, Christine Lippitt and Rosalyn Robertson, who were enthusiastically involved in this project.

Vance Barrie, Coordinator of Marketing for the Rockford Park District, who made available the District's large collection of pictures that span over 150 years.

John Molyneux, Rockford Public Library Historian, who provided insights into the early days of Rockford.

Mike Babcock, Kristan Dolan, Todd Fulk, all administrators for the Rockford RiverHawks Professional Baseball Team, and Aaron Johnson, team photographer. They opened-up their team files of pictures and other RiverHawks information to me.

John Melin, whose mother "Berry" was a member of the Rockford Peaches during their inaugural year, provided pictures from her baseball career.

The author is especially indebted to Doris Calacurico Johnson, a former bat girl for the Rockford Peaches, and an outstanding young baseball player herself, for sharing with me her extensive and never before published collection of Peaches "snapshots," and other artifacts from the Peaches, including those of her sister, Aldine Calacurico Thomas, who during the 1947 was a utility shortstop/infielder for the Peaches.

The author is indebted to Jeff Ruetsche, the Arcadia Publishing Sports Editor, for his expertise and guidance throughout the writing of this book, and to Mike Spiegel, for his work with the photographs.

INTRODUCTION

ILLINOIS BECAME A STATE in 1818, with the early settlers claiming land in the southern portion. An 1826 geography book states, "The white population lives in the southern part of the state, the northern part belongs to the Indians." That changed after 1832, when Chief Black Hawk, and approximately 1,500 followers, crossed the Mississippi from their treaty-deeded area in what is now Iowa and attempted to re-claim the land in the Rock River Valley that they had previously held. These events became known as the "Black Hawk War." Among the soldiers that came to the area to fight the Indians were two men who less than 30 years later would assure their places in history—Abraham Lincoln and Jefferson Davis. When the Indians were defeated late in the summer of 1832 and returned to Iowa, the area was considered to be safe for settlement, and a significant number of new settlers began arriving in the Rock River Valley.

The area had rich soil for farming, waterpower for manufacturing, and a means of transportation with the Rock River that flowed all the way to the Mississippi River. Commerce began to develop, and in the summer of 1852 railroad tracks were completed, and the first steam engine arrived, connecting Rockford with Chicago and Lake Michigan. Rockford's place in history as a rapidly developing city was assured. It quickly became the dominant town in the area. Within its legal boundaries the U.S. Census Bureau determined a population of 8,117, with a significant number of others living on farms and in small villages in the nearby area. Rockford became known as "The Forest City" because of the thousands of elm trees that were growing throughout the town—and it was this nickname that the city's most prominent nineteenth century baseball club would adopt.

During the Civil War, prosperity in Rockford continued in all aspects of the War effort. A military training facility, Camp Fuller, which was established within the towns boundaries, trained three regiments of Northern Illinois volunteer soldiers and sent them off to fight under General Grant. There is no written or pictorial evidence of baseball being played at Camp Fuller, or in the town of Rockford during the Civil War, but its well-recorded popularity immediately after the War suggests that some residents were familiar with the game, and certainly the returning veterans had been exposed to it during the war.

The "Forest City's" team emerged in 1866, and was reported to have had 150 sponsors. They persuaded the best players in the area to play for their team, including a young pitcher named Albert Goodwill Spalding. Over the next several years, they played other teams in the Midwest, and induced other outstanding players to come to Rockford and play for the Forest City team.

The Forest City team first gained national attention on July 5, 1867, when they, with Albert Spalding pitching, defeated the touring Washington Nationals, which was considered to be the best team in the country and was undefeated so far that year. That event put Rockford and its Forest City team on the national baseball map. In 1868 they beat Chicago to win the

"Northwest Championship." In 1869 they had a 20-4 record. In 1870 Rockford businessmen increased their financial support for the team and pledged $7,000 to send it on an extended tour of the east to play the best teams in the major eastern cities. The Rockford team was very successful, and with Albert Spalding pitching and position players like Barnes, Addy, Stires, and others, they won 51 games, lost only 13, and tied one. The tour was economically successful, and that success led to a special invitation from the big city teams.

In March of 1871, a Rockford Forest City Baseball Club representative traveled to New York City to meet with representatives from other baseball cities for the purpose of establishing the first major league, to be called the National Association. In addition to Rockford, other cities to join the first major league were Philadelphia, Boston, Chicago, Troy, N.Y., Washington, D.C., Fort Wayne, New York City, and Cleveland. Although the 1871 Forest City team had some good players, prior to the start of the season their star pitcher, Albert Spalding, had been induced to play for Boston and was financially rewarded for doing so. The 1871 season, in which Rockford was one of the first major league members, was a disaster for the team, the city, and the businessmen who financially supported the team. In 1872 the National Association continued without Rockford.

Major league baseball had died forever in Rockford with the demise of the 1871 Forest City Baseball Club, but the game continued at an amateur local and regional level. Then, in 1879, Rockford joined Omaha, Dubuque, and Davenport in forming what has been described as being the first "professional minor league." However, the league met its demise after only one season. Between 1888 and 1923 several professional minor league teams, and the Midwest leagues that

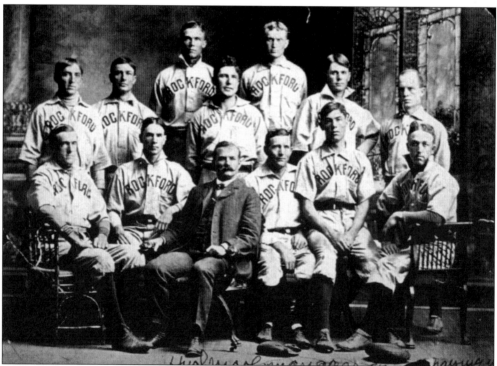

This 1892 Rockford team played in the Illinois-Indiana League with Evansville and Terre Haute, Indiana and Jacksonville, Joliet, Peoria/Aurora (the team moved mid-season), Quincy, and Rock Island-Moline, Illinois. The manager, Hugh Nicol, had played 10 years in the major leagues (1881-1890). The Rockford team dropped out of the league at the end of the 1892 season. Hugh Nicol made it back to the majors again in 1897, as manager of the National League St. Louis team. (Courtesy of Rockford Park District.)

they played in, were established in the Forest City. These, too, were usually disbanded within a few seasons.

From 1924 to 1943 Rockford had no professional baseball teams. Its amateur teams thrived, especially those in the popular "industrial leagues," which since the early 1900s in Rockford consisted of company-sponsored teams made up of their employees, with uniforms, equipment, and expenses paid for by the companies. The teams played other company nines, sponsored in a similar manner, before crowds of fellow employees and interested spectators. The local newspapers reported on the games, standings were kept, and tournaments were held. In addition to the industrial leagues, there were local clubs that competed with teams from other communities in the area. Also popular were the "church leagues" in which uniforms, equipment, and other expenses were paid by the individual churches and their congregations.

Having been without organized professional baseball for 20 years, the City of Rockford was elated to welcome in 1943 the "Rockford Peaches," its own team in the highly competitive and very popular "All American Girls Professional Baseball League," the first professionally organized team sport for women in the United States. A charter member with continuous league membership until the League disbanded in 1954, the Rockford Peaches team, and its players, were very successful in competition with the other teams, winning four league championships—1945, 1948, 1949, and 1950. Attention was again called to the Peaches in 1988 when the National Baseball Hall of Fame in Cooperstown, New York established a permanent exhibit where League pictures, uniforms and equipment are displayed, and especially some artifacts that had belonged to members of the Peaches and some of their star players. In 1992 the Peaches were again called to the attention of the nation when the movie *A League of Their Own* became a box office hit.

During the Peaches run in Rockford, another men's professional team appeared, the Rockford Rox, a Class A minor league team for the Cincinnati Reds of the National League. The Peaches out drew the Rox, both in attendance and in the love of the Rockford fans, and the Rox lasted only three seasons, 1947 to 1949. By 1955, Rockford was again without a professional baseball team, women's or men's. However, the city didn't stop playing baseball. The various adult leagues remained popular and now hundreds of young boys and girls were playing in Little Leagues, Pony Leagues, Boys Club, American Legion, and a variety of other leagues where they were organized, had uniforms, coaches, proper equipment, played a regular schedule of games; and in some seasons Rockford hosted the league regional championships and even world series. Some of the local players, having honed their baseball skills in the various Rockford-area amateur leagues, would eventually make it to the professional level, and, for the select few, even the majors.

Professional minor league baseball returned to Rockford in 1988, when the Montreal Expos placed their Midwest League Class A team in the Forest City. In 1993 they were replaced with a Kansas City Royals team, and from 1995 through 1998 the Chicago Cubs "Cubbies" were Rockford's team. When the Cubbies departed, Cincinnati placed their Reds Class A team in Rockford for the 1999 season. Although reasonably well supported by Rockford fans, teams left town because minor league baseball was experiencing a nationwide boom in popularity, and other cities in the Midwest had built or promised to build beautiful, multi-million dollar stadiums that would draw huge attendance numbers. Rockford had no such stadium. Cities made many promises to the major league organizations in order to lure their minor league teams, and the Rockford franchise was thus lured to Dayton, Ohio in 1999.

Rockford institutions worked hard to bring professional baseball back to the city. Rockford already had professional minor league teams in basketball, soccer, and ice hockey that were receiving community support. However, during the 2000 and 2001 seasons, the attractive and versatile Marinelli Stadium, which had been the home of the previously discussed minor league baseball teams, was hosting only high school, college, and other amateur sporting events. There was a void to be filled by a professional baseball team.

Prior to the 2002 season, the community became excited to learn that it was going to have professional baseball again. The independent Frontier League of Professional Baseball was

interested in placing an organized, but yet to be named, team in Rockford. A local poll was held to select a name for the new team. Fans selected the name Rockford RiverHawks. The team played well, and was well marketed by experienced professionals. Throughout the season various promotions that often included give away gift items brought fans to the RiverHawks games. The club averaged over 2,100 fans a game in its initial season, and the RiverHawks are looking forward to an exciting season in 2003, and many more to follow.

As readers can determine, Rockford, the second largest city in the Illinois, with a population of over 150,000 residents in a metropolitan area of over 400,000—and lots of local baseball fans—has both a rich and a continuing baseball history. These pages will tell the story of that history.

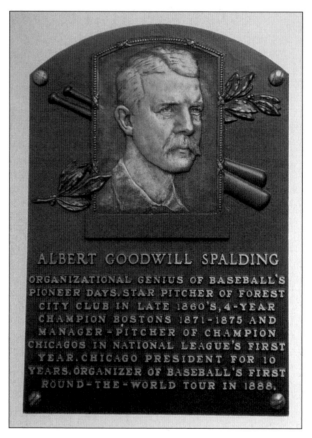

Among the charter members inducted into the National Baseball Hall of Fame in 1939 was A.G. Spalding, whose bronze plaque reads:

> Albert Goodwill Spalding....ORGANIZATIONAL GENIUS OF BASEBALL'S PIONEER DAYS, STAR PITCHER OF FOREST CITY CLUB IN LATE 1860'S, 4-YEAR CHAMPION BOSTONS 1871–1875 AND MANAGER-PITCHER OF CHAMPION CHICAGOS IN NATIONAL LEAGUE'S FIRST YEAR. CHICAGO PRESIDENT FOR 10 YEARS, ORGANIZER OF BASEBALL'S FIRST ROUND-THE-WORLD TOUR OF 1888.

These posthumous statements about Spalding provide only a tiny glimpse of the major impact and influence that Spalding had upon the early days of baseball and its strong influence on the American culture. (Courtesy of the National Baseball Hall of Fame, Cooperstown, NY.)

ONE

Albert Goodwill Spalding

ROCKFORD'S
NATIONAL CELEBRITY

ALBERT GOODWILL SPALDING was born to Harriett and James Spalding September 2, 1850, in a log-and-frame house in Byron, Illinois that is still occupied. When he died in Port Loma, California, September 9, 1915, he was a multi-millionaire who, in addition to being remembered for all of the accomplishments listed on his National Baseball Hall of Fame bronze plaque, had also founded the most successful sporting goods company in the world.

Albert's father, James, passed away at age 47, when Albert was only nine years old. He left a widow and three children without a husband and father, but with considerable financial holdings for that period of time, including a house and three farms. Concerned about Albert's education, when he was 12 years old his mother sent him to live with an aunt in the prospering town of Rockford, only 14 miles to the north of Byron. His mother, sister, and brother soon joined Albert in Rockford.

By the time of the arrival of the Spaldings in 1864, the town had a population of approximately ten thousand residents, and was regarded a prosperous community, filled with opportunities. It had early on established itself as an industrial town, an image that it has maintained to the present day. By the mid-1860s, business and industry were thriving, and Rockford's citizens had time to look for recreational activities—just in time for the post-war spread of the burgeoning national pastime, baseball.

Albert, in his biography, described himself as being "a lonely boy who was afraid to venture from his home until he discovered the joys of baseball." On playgrounds his baseball skills were recognized, and he was asked to join a boys team called the "Pioneers." Albert and his teammates were successful in games with other boys' teams and Spalding found his niche as a pitcher, but he was also a very good hitter, or striker, as the batter was then called.

Feeling confident of their skills, the Pioneers challenged the best men's team in town, the Mercantiles, to a game, and with Albert pitching—they won. Although only 15 years old, he was invited to join a new team of adults that was being formed to challenge other teams from cities throughout the Midwest. This adult team was organized by local businessmen, some of the most influential men in Rockford, and was named the Forest City's, in reference to the many elm trees that populated the city and its streets. Albert and his Forest City's teammates could stand proud in their new uniforms.

During the 1866 season, the Forest City's played against other teams in Northern Illinois and Southern Wisconsin, and established themselves as formidable opponents. In 1867, the Rockford Forest City's entered a tournament held at Dexter Park in Chicago, a tournament that featured many top teams, including the previously undefeated Washington Nationals, considered to be the best team in the country. The Nationals were essentially professionals.

They were on the payroll as United States Government clerks, but most months they earned their wages by traveling with the team and playing other teams and drawing paying customers to ballparks across the country. With Albert Spalding pitching, the Rockford Forest City's won the game 29-23. Albert and his team became the "toast of baseball." It was the Nationals only loss that season. The Forest City's continued to do well over the next two seasons and earned the informal title of "the champions of the West."

In 1870, in addition to Forest City's regular schedule with Midwest teams, Rockford businessmen raised $7,000 to send the team on a 17-game eastern tour with games in Canada, New York, Massachusetts, Pennsylvania, Ohio, and Washington, D.C. The Rockford team won 13 games, lost three, and tied one; and they beat the only admittedly professional baseball team, the "world champion" Cincinnati Red Stockings, by a score of 12-5. Albert Spalding pitched all of the games and earned considerable national attention with his unique pitching style.

At the end of the 1870 season the leading teams in the nation met and created a new organization, which they named the "National Association of Professional Base Ball Players" (NAPBBP), now recognized as the first major league. The Cities joining the National Association were Philadelphia, Chicago, Boston, Washington, DC, New York City, Troy, NY, Fort Wayne, Cleveland, and Rockford. Playing from 25 to 30 games each, the final 1871 standings found them finishing in the order listed above, with Rockford being last. Rockford won only 6 games and lost 20 that season, largely because their star pitcher, Albert Goodwill Spalding, had been induced to play for Boston, and was one of its highest paid players; and another former Forest City's star, Roscoe "Ross" Barnes, joined Spalding in Boston.

The 1871 season, in which the Rockford Forest City Team (before 1871 called the Forest City's, and after 1871 called the Rockford Forest City Team) was one of the first major league teams, was also the last for the Forest City Team. In 1872 the National Association continued, but without Rockford. However, five of the downtrodden 1871 team members—Adrian Anson, "Cherokee" Fisher, Ralph Ham, Scott Hastings, and Denny Mack—had established themselves as major league level ball players and were signed by other National Association teams.

While a young man still in Rockford, Spalding had been guided by several local businessmen. Now, during his tenure in Boston, Spalding gained two additional mentors who would strongly influence his life. Both are enshrined in the National Baseball Hall of Fame in Cooperstown, New York. In addition to being one of Boston's star players, part owner, and manager, Harry Wright had established a successful sporting goods company. It was also Wright who included Spalding in his plans to take the team on tour to England following the 1874 season. That entrepreneurial spirit made a strong impression upon Spalding, and would lead to the founding of The Spalding & Bros. Corporation, which became the dominant supplier of sporting goods and equipment in the world.

During the 1875 season, the second mentor came into Spalding's life. William Hulbert, a successful businessman and part owner of the National Association's Chicago team, approached Spalding and encouraged him to return to the Midwest and join him, not only as the player-manager of his team, the Chicago White Stockings, but also as a part-owner. What Hulbert really wanted was for Spalding, as the dominant force among the players, to help found a new major league, the "National League of Professional Baseball Clubs," using Spalding's status to lure other top players away from the National Association.

Albert Spalding, a complete gentleman, agreed with Hulbert that the game needed to be cleaned up, that many of the players were too rowdy, were sometimes drunk while on the field, and that too much gambling and other corruption was taking place. Together they proposed that the only solution was to disband the current league and remake it, even against the protests of other clubs and players. What Hulbert and Spalding proposed was a new league, with full control in the hands of the teams and not the players, and a league president having overall control of all ball clubs.

During their secret meetings it was determined that Hulbert would cultivate the acceptance of the owners for this new league, and that Spalding would cultivate the acceptance of the players. Both Hulbert and Spalding were in complete agreement that baseball had a great future in America, but only if the game's reputation was put beyond reproach. As reformers, Spalding

and Hulbert were determined to eradicate open gambling and liquor sales in the ballparks, to expel clubs that did not follow established game schedules, and to make baseball into a game that would attract decent people and their families, including women.

William Hulbert and Albert G. Spalding are correctly called "The Fathers of the National League," for without their early influence, and the respect that each received from their peers, the other players and clubs probably would not have followed, at that time, in the creation of the National League of Professional Baseball Clubs that has now existed for over 125 years.

In the inaugural 1876 season all teams played a 70-game schedule, each team playing each of the other teams ten times. It was determined that the team with the most victories would be declared the champions and would receive a "pennant" costing less than $100. In that inaugural season Spalding the manager guided his team, the Chicago Whitestockings, to a pennant-winning 52-14 won-loss record (four games were not made-up because Chicago was far ahead of the others). Spalding the pitcher pitched his way to a 47-13 won-loss record, clearly the best record in the league. Spalding the business partner helped William Hulbert to demonstrate that a professional baseball team could be a financially successful business operation.

After the 1877 season, although still in his physical prime, Albert Spalding called it quits as an active player and manager. He was secretary of the club from 1878 to 1882, and then owner-president upon the unexpected death of William Hulbert in 1882. His team won National League championships in 1880, 1881, 1882, 1885 and 1886. Under Albert Goodwill Spalding's leadership they were the best team in the National League. Three players from those teams—Adrian Anson, John Clarkson, and Mike "King" Kelly—would be inducted into the National Baseball Hall of Fame in Cooperstown New York.

In 1899 Albert Spalding's wife of 30 years passed away. He soon after married a childhood acquaintance from Rockford, Elizabeth Mayer Churchill. By 1900 they were living on their private estate, within a religious colony located on Point Loma, California, just north of San Diego. From that location he was able to travel back to the east and Midwest whenever necessary by train, yet enjoy the beautiful estate upon which he lived and the climate that he preferred. On September 9, 1915, at the age of 65, Albert Goodwill Spalding succumbed to a major stroke. His body was cremated and his ashes cast into the Pacific Ocean, off of Point Loma, according to his wishes.

Albert Goodwill Spalding, whose early roots were in Rockford, strongly shaped American culture through his many contributions, not only in baseball, but also in many other areas in which he was involved. He was an outstanding American whose legacy has lived on well past his death in 1915.

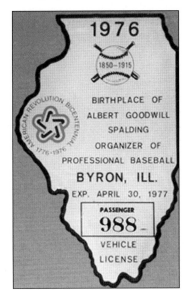

Byron, Illinois is very proud of its most famous son and in 1976, in celebration of the USA Bi-Centennial, publicized Spalding on its vehicle tax sticker. (Author's Collection.)

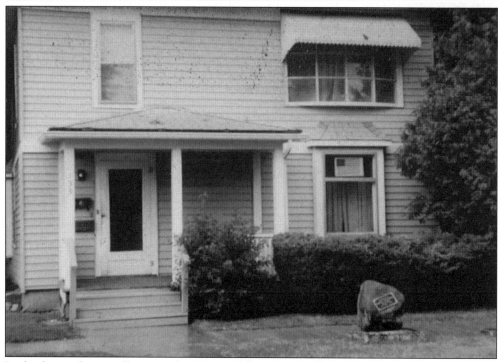

In this house that is still occupied in Byron, Albert Goodwill Spalding was born on September 2, 1850 to Harriett and James Spalding. (Author Collection.)

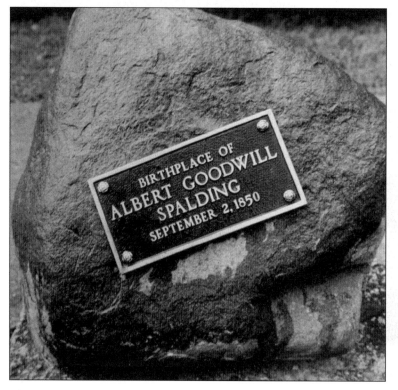

This bronze plate on the boulder commemorates the event of Spalding's birth. It is maintained by the A.G. Spalding Commission, Byron. Although Spalding maintained that he never played baseball until he lived in Rockford, his birthplace of Byron, too, developed a rich baseball heritage of its own and sponsored many baseball teams, both youth teams and adult teams. (Author Collection.)

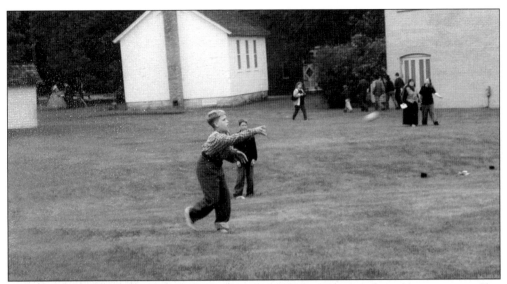

A modern-day Albert Spalding at this vintage baseball reenactment demonstrates some of his early pitching skills. The pitcher at that time stood only 45 feet from the batter, and was required to throw underhand, releasing the ball below the waist. The emphasis was on the pitcher outwitting the batter, and making the ball do strange things by applying spit, tobacco juice, sand paper, and other devious but legal alterations to the ball. Players essentially played without equipment, except for bats and balls. (Author collection.)

This picture, taken at a 1996 reenactment, might resemble Albert and some of his "Pioneer" teammates. (Author Collection.)

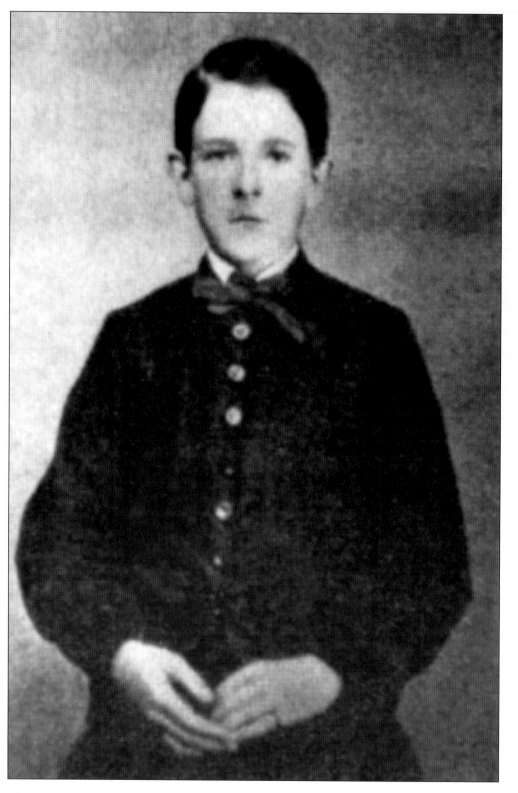

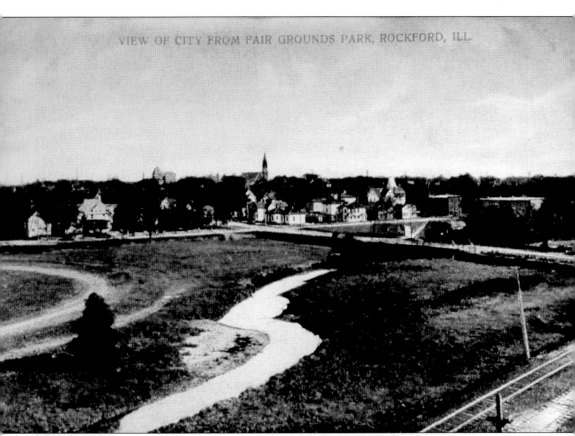

The "home games" of the Forest City's were played in Fairgrounds Park on the West Side of Rockford. Fairgrounds Park was the annual site of the Winnebago County Fair, as well as many other recreational activities, including a horse racing course (part of the oval can be noted in the left of this vintage picture). This horseracing course had a sizable grandstand surrounding the start and finishes area for spectators to sit in and be shaded from the sun. It was also fenced with an admission gate, where entrance fees could be collected. The baseball diamond was located within the oval of the race track, a common practice in many cities during that period of time. To this day the interior of the oval at major racetracks is still referred to as "the infield." Fairgrounds Park still exists on its original site, a property of the Rockford Park District. It contains several softball diamonds and a swimming pool, but no race course. (Courtesy of the Rockford Park District.)

Opposite: Albert Spalding pictured at age 12, when he moved to Rockford, Illinois, a town 14 miles north of Byron. It was in Rockford where he gained his early fame in baseball. (Courtesy of the Spalding Commission, Byron Public Library.)

17

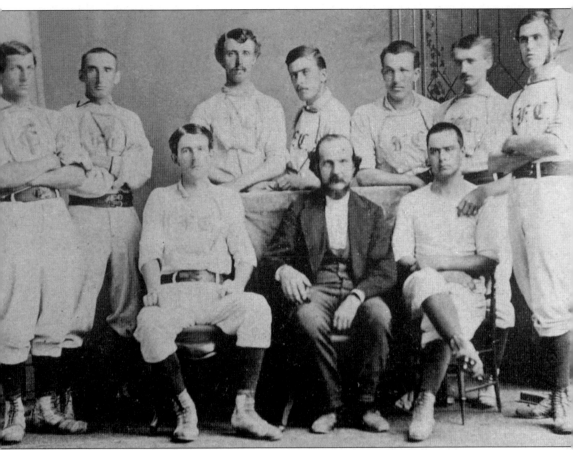

Pictured is the 1866 Forest City's team of Rockford. It was in this year, the first full spring after the end of the Civil War, that soldiers who had learned the game of "base ball" from their eastern companions returned home to form amateur "nines" throughout the states. Substitutions were rare, and a club would typically field the same nine players game after game, for the entire match. Spalding is seated on the left. Ross Barnes is standing third from left, and Bob Addy is standing second from left. In 1865 Spalding and Barnes were playing on a team called the "Pioneers;" all members were no older than 15. That team challenged one of the two best men's teams, the "Mercantiles" to a game. Much to the delight of the other top men's team, the Forest City's, who were spectators, the youth team won, 26-2, and both Spalding (pitcher) and Barnes (second base) were invited to join Forest City. (Courtesy of A.G. Spalding Commission, Byron Library.)

Opposite: Baseball in 1860, the game which Spalding played as boy, would certainly be recognizable to fans of today's game, although with some curious differences. Seen in this vintage "base ball" reenactment at the Rockford Midway Village and Museum Center, the ball is pitched underhand and over the plate to the batter—called the striker—who, like today, has three strikes to an out; there are no called balls or strikes; and a fly ball caught on one bound constitutes an out. There was one umpire, selected by the captains of the competing clubs, and substitutions were allowed only in the case injury or illness. At this early stage rules changed from year to year and region to region.

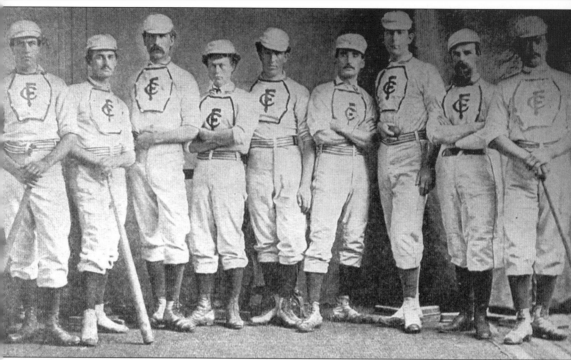

The talented 1869 Forest City's, from left to right, are T.J. Foley (third base), R.C. Barnes (shortstop), A. Harker (left field), D. Sawyer (center field), Fred Cone (first base), R.E. Addy (catcher), A.G. Spalding (pitcher), G. King (right field), and S. Hastings (second base). This 1869 picture essentially portrays the Forest City's team that played together from 1866-1869. A few players from that period are missing from the picture, including "Gat" Stires. They were regarded as a very good regional team. That season they played 24 games of record, beating all of their opponents except for four losses to the undefeated Cincinnati Red Stockings, the only acknowledged professional team at that time. (Courtesy of the A.G. Spalding Commission, Byron Public Library.)

The 1870 Forest City's Baseball Team clearly demonstrated that it was one of the best teams in the country and could compete with the best of the best of the "big city" teams. (Courtesy of A.G. Spalding Commission, Byron Library.)

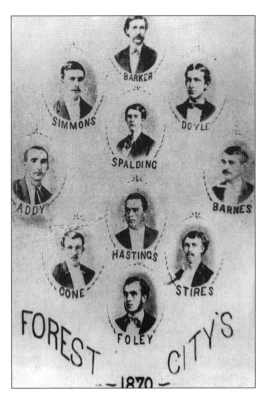

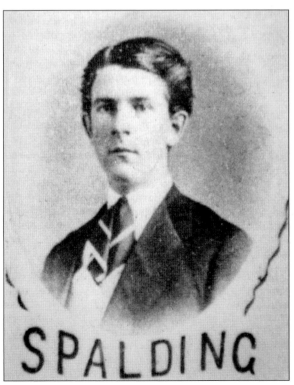

Spalding again proved to be a dominant pitcher in 1870. The 1870 Forest City's went on tour against some of the best Eastern United States teams and, led by Spalding's pitching, established a 65-14 won-loss record.

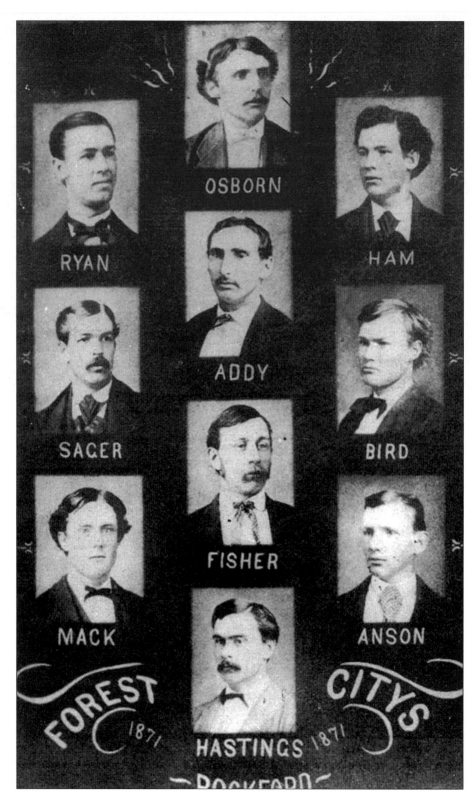

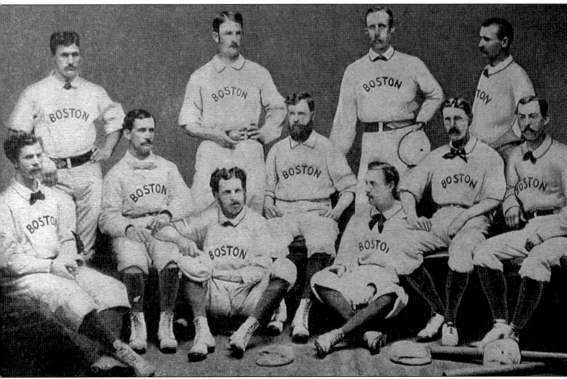

Despite the demise of his former Rockford teammates, Albert Goodwill Spalding found great success with his new team in Boston. Many of the Boston players, including its two biggest stars and leaders, George and Harry Wright, had played for the Cincinnati Red Stockings during the seasons prior to 1871. They were the first team that openly paid their players and called them professionals.

Albert Spalding was the National Association's dominant pitcher, with season won-loss records of 20-10, 37-8, 45-15, 52-18 and 57-5. Throughout Spalding's five seasons playing for the Boston Red Stockings, Henry Chadwick, a highly respected sports writer, touted not only Albert Spalding's baseball skills, but also his character, both on and off the field, citing his high ethics, his avoidance of alcohol, gambling, and swearing, and his faithful service in all aspects of the game and in life. Chadwick continually presented him as the model for other players to follow, a "thorough representative of the spirited young men of the western states," and somehow Spalding did not seem to draw resentment from other players for the accolades that he received. He was accepted by the others for his manly play and deportment, a social skill that he was able to further cultivate and use to his advantage throughout his life. (Courtesy of the A.G. Spalding Commission, Byron Library.)

Opposite: The 1871 Forest City Baseball Team of Rockford was the City's only "major league" team. Rockford had to forfeit the first two games of the 1871 season because their catcher, Hastings, was still under contract to another team at the time. Later, some of the other teams refused to come to Rockford because of transportation expense, insisting that Rockford's home games be played in Chicago. The final blow was that their October games couldn't be played in Chicago, because the Great Chicago Fire had just destroyed much of the city, including the Lake Street Ball Park where the games were to be played. (Courtesy of the A.G. Spalding Commission, Byron Library.)

Pictured is A.G. Spalding the business man. Spalding and his partner William Hulbert met with representatives from other cities in New York City, and on February 2, 1876, created the National League. They began by establishing four franchises in the west—Chicago, St. Louis, Cincinnati and Louisville,—and, for geographical balance, four more in the east—New York, Boston, Philadelphia, and Hartford. All had populations well over 75,000, and all were connected by railroad. (Courtesy of the A.G. Spalding Commission, Byron Library.)

The Chicago franchise is the only one to be in continuous operation for all 128 years of the National League (1876-2003). The Chicago team was named the White Stockings, a name that they kept until 1890. It wasn't until 1902 that they started being called the Cubs, and it wasn't until 1907 that Cubs became the official nickname. Since its founding in 1876 to this day, the legal name is Chicago National League Ball Club, Inc. Contributing to the successful season of 1876 were two former Forest City teammates of Spalding—Adrian Anson, the star first baseman who Spalding named the team's captain, and Ross Barnes, who won the first National League batting championship. Both had played for the Rockford Forest City Team, and Barnes was a native of Rockford. (Courtesy of Transcendental Graphics, Boulder, Colorado.)

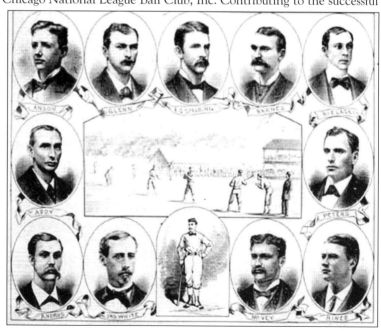

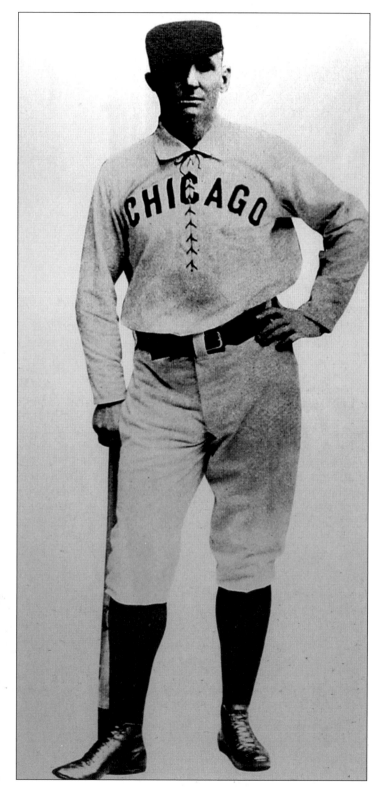

An inaugural inductee into the National Baseball Hall of Fame (along with Spalding) in 1939, Cap's bronze reads:

Adrian Constantine "Cap" Anson Greatest hitter and greatest National League Player-Manager of the 19th Century. Started with Chicago in National League's first year 1876. Chicago Manager from 1879-1897 winning 5 pennants. Was a .300 class hitter 20 years, batting champion 4 times.

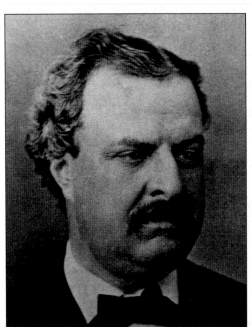

Hulbert's bronze at the National Baseball Hall of Fame reads:

William Ambrose Hulbert—Wavy haired, silver tongued executive and energetic, influential leader while part-time owner of Chicago National Association team. Was instrumental in founding National League in 1876. Elected NL President later that year and is credited with establishing respectability, integrity and sound foundation for new league with his relentless opposition to betting, rowdiness, and other prevalent abuses which were threatening the sport.

Hulbert, mentor and partner of A.G. Spalding in the founding of the National League and the Chicago White Stockings, is buried in Chicago, at Graceland Cemetery. When he died in 1882 Hulbert was not only the President of the Chicago team, he was also President of the National League. His death placed Spalding in full control of the White Stockings, and increased his administrative responsibilities, both with the team, and also with the League. In this role Spalding continued to gain much national influence, acclaim, and control.

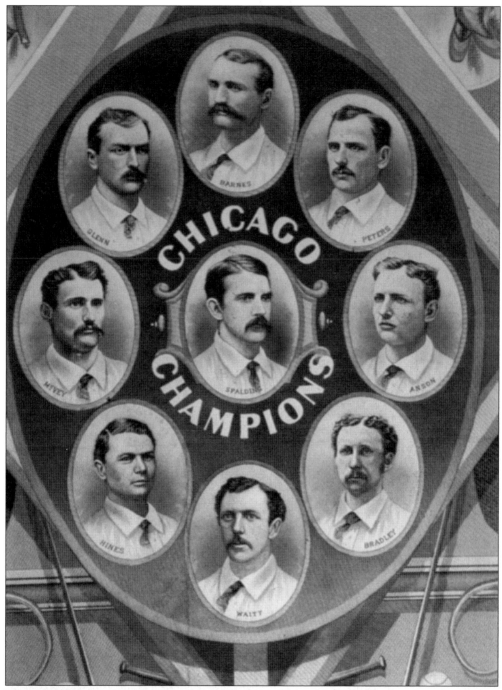

The 1876 National League Champion Chicago White Stockings. (Courtesy of the A.G. Spalding Commission, Byron Library.)

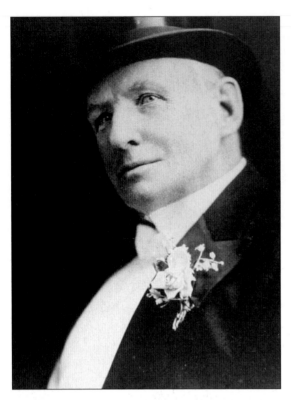

Anson's rugged appearance would never bring anyone to call him a "dandy," but he was always appropriate in what ever setting he was in. He was distinguished looking and dressed well, which added to his mystique. (Courtesy of the A.G. Spalding Commission, Byron Library.)

In his later years, Anson was comfortable on a theater stage and often performed with his two daughters. "Cap" Anson was a very versatile individual who did things "his way." (Courtesy of the A.G. Spalding Commission, Byron Library.)

HOYT'S A RUNAWAY COLT.

HOYT & McKEE PROPRIETORS

CAPT. A.C. ANSON.

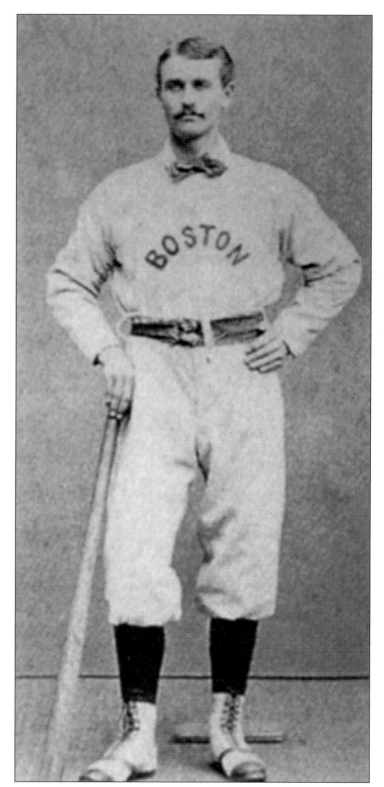

Roscoe "Ross" Barnes, pictured here while a member of the Boston Red Stockings team, was one of the greatest players of his time. He batted over .400 twice while playing for Boston in the National Association, and was the first National League Batting Champion (1876) while playing for the Chicago White Stockings. Ross, a close personal friend of A.G. Spalding, played with him in Rockford, Boston and Chicago. (Courtesy of the A.G. Spalding Commission and Byron Library.)

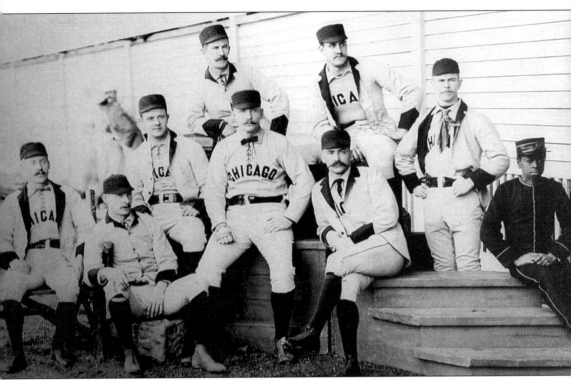

Adding further to his administrative skills, Spalding planned, and from October 1888 to April 1889 carried out, what was correctly labeled "the greatest event in the history of athletic sports." He led a group of the best baseball players of the time on a world tour that included 42 exhibition games, played before an estimated 200,000 people in some of the major cities in the world, followed by a two week tour with exhibition games played in nine Eastern and Midwestern cities.

Upon the return of the touring teams to Chicago on April 19, 1889, Spalding and his associates were welcomed with festivities and a parade that was attended by more than 150,000 spectators. In its final financial accounting of the tour and tour expenses, it appeared that Spalding lost $5,000. However, he and his associates were convinced that the exposure that he and his sporting goods company had received in introducing to the world the game of baseball, and demonstrating its quality equipment, made the tour a very profitable experience.

This picture shows some of the touring players and the team mascot. In the center of the picture is Adrian "Cap" Anson, former Rockford Forest City Team player and the man whom Spalding appointed to be his Chicago White Stockings captain, beginning in the National League's first season, 1876. Anson was appointed the team's manager in 1879 and continued through 1897, winning .575 of his National League games and six first place finishes. Regarded by many as being the most outstanding player of his time, Anson was inducted into the National Baseball Hall of Fame with the first group of inductees, in 1939. (Courtesy of the A.G. Spalding Commission, Byron Library.)

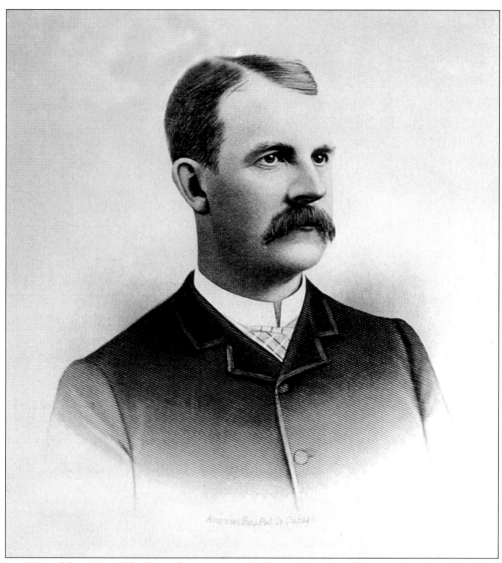

In 1891, although still holding the majority of the stock in the Chicago franchise, Spalding gave up most of the leadership in the Chicago club and settled in to a role as an elder statesman. He was very distinguished looking, always impeccably dressed, very stylish, and was described by one observer as having "the manner of a Bishop." Much of his attention was now given to his thriving sporting goods business. (Courtesy of A.G. Spalding Commission, Byron Library.)

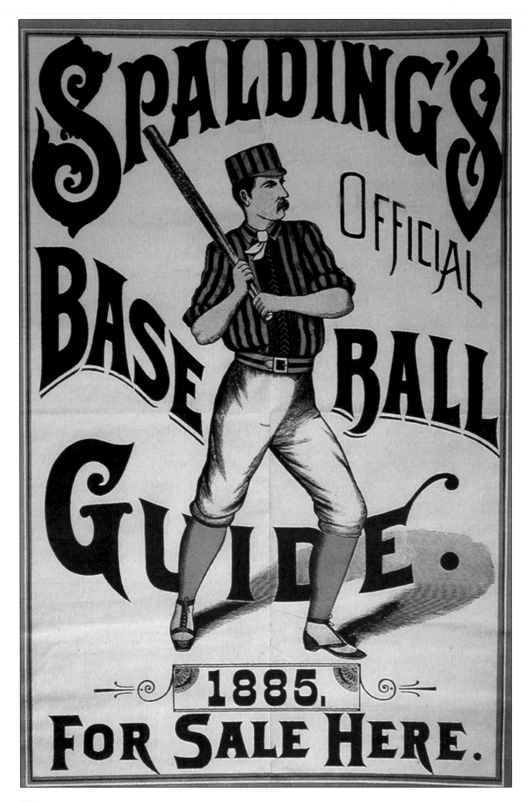

Soon the A.G. Spalding & Brothers Company was not only supplying the majority of baseball equipment to teams all across the United States, they were also supplying equipment and uniforms to participants in other sports. They entered on the "ground floor" at the early stages of a sport or games popularity. (Courtesy of the A.G. Spalding Commission, Byron Library.)

Opposite: During the 1871-1875 seasons, while playing in Boston, Albert G. Spalding observed that his mentor, Harry Wright, was having some success with a sporting goods business that he had developed, supplying teams with uniforms and equipment. This made an impression on Spalding, and when he moved to Chicago the entrepreneurial fire in Spalding was lit. He began on a road to fame and fortune by founding the A.G. Spalding & Bros. Sporting Goods Corporation, together with his younger brother, Walter, and his brother-in-law William T. Brown. It has been reported that they received financial assistance from their mother Harriett Spalding, who lived in Rockford, and Brown's father, a prominent banker in Rockford. Over the years they developed and maintained their position as the leader in the field of sports equipment and sports publications.

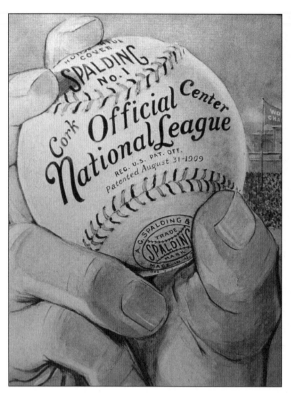

The Spalding & Brothers Corporation found that publishing baseball guides, beginning in 1877, could be very profitable. In addition, they published guides and rule books for almost all popular sports. Of course, the guides included advertising for Spalding equipment.

Al Reach, a National League player and close friend of Albert Spalding, was encouraged to become a friendly competitor. Spalding maintained a one-half interest in the Reach Corporation. Many of the players listed on these pages were listed in the "Guides."

34

The Spalding Baseball was the only official and authorized baseball for the National League for 100 years. Albert Spalding and his partners recognized that the ball was the one key element for defining the game and it's equipment. Albert astounded all of the owners and administrators of the other teams by suggesting that not only would the A.G. Spalding & Brothers Corporation supply the baseballs to all of the other National League teams free of charge, they would also donate one dollar to the National League for each dozen baseballs that were used. This official association between the National League and Spalding quickly established the new company as being the provider of quality equipment for baseball at all levels. (Author Collection.)

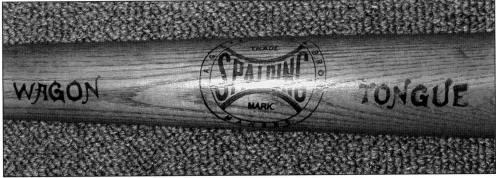

In baseball, along with the ball, the most important piece of equipment is the bat. In early baseball players chose and defined their own bats, which could be broom handles, shovel handles, carved sticks, or whatever individual players had handy. Companies, including Spalding, made official bats and encouraged players to purchase them. Although the Spalding Company sold bats of various qualities to various levels of players, their high priced "Wagon Tongue" model was very popular among the top players. Made from sturdy oak originally chosen to be made into wagon tongues, the model provided the weight, strength, and durability that players wanted. (A.G. Spalding Commission, Byron Library.)

A long-retired Spalding puts on an exhibit of his legendary pitching and hitting skills at an "old-timers" game in Boston in 1908. He was 58 years old at the time.

One of Albert Goodwill Spalding's contributions to baseball late in his life was the determination of "the origins of the game." To accomplish this task, Spalding in 1905 instituted a commission whose members represented nationally recognized officials and leaders with impeccable reputations, most of whom had a baseball background. The commission's report concluded that baseball had American origins, and that it was invented by Abner Doubleday, a respected U.S. Army General, and that he taught the rules of the game to his friends in Cooperstown, New York in 1839. These findings were announced and reported in depth in Spalding's book that was published and marketed in 1911, titled *America's National Game*. Critics have since questioned those findings, which baseball historians now refer to as the "Doubleday Myth." Nevertheless, the National Baseball Hall of Fame is located in Cooperstown, New York, and is attended by millions.

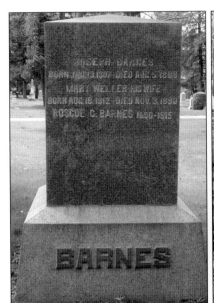
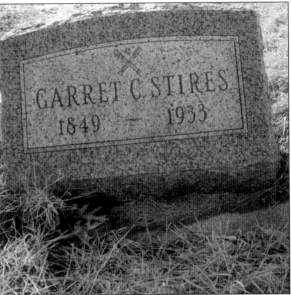
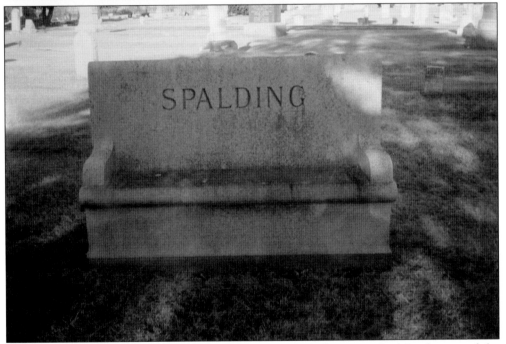

Top left: Roscoe "Ross" Barnes, star player with Forest City, the Boston Red Stockings, and the Chicago White Stockings is buried in his family plot in Greenwood Cemetery, Rockford.

Top right: The grave of a close childhood friend of Albert G. Spalding, and famous baseball player in his own right, Garrett "Gat" Stires, can be observed near the Spalding plot, and identified by the crossed bats and ball engraved upon his tombstone.

Bottom: The "Spalding bench" in the Byron Cemetery marks the family plot. Only James Spalding and Harriett Spalding have visible gave markers forward and to the right of the bench. Contrary to a local Byron legend, Albert's ashes were not spread on the family plot. They were cast into the Pacific Ocean off of Point Loma, California. (Author Collection.)

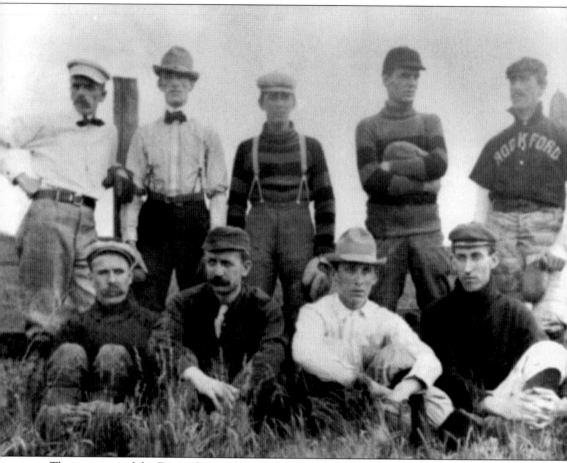

The successes of the Forest Citys and A.G. Spalding would help promote the popularity of the game throughout the Rockford area, and it was not just the professionals who would take up the bat and ball to play the national pastime. Pictured is a group of local amateurs, *c.* 1900. (Courtesy of Rockford Midway Village and Museum Center.)

TWO

Amateur Baseball in the Rock River Valley

AMATEUR BASEBALL HAS PLAYED a major role in the Rockford area since the 1860s. Teams were formed that competed against other teams within the city, and against teams from other towns and villages that made-up what has been known as the "Rockford Metropolitan Area," and is unofficially regarded as those towns that lay within a 20 mile radius of the city. Among those towns were Belvidere, Marengo, Stillman Valley, Rockton, Roscoe, South Beloit, Pecatonica, Byron, Durand, Polo, Loves Park, Winnebago, Kirkland and Rochelle.

Just beyond the edge of that 20 mile radius lay several towns of some size that provided worthy opponents for recreational baseball games. Those towns included Beloit and Janesville in Wisconsin, and Illinois neighbors such as Freeport, Dixon, Oregon, DeKalb, Sycamore, Harvard, Woodstock, and others. Within Rockford games could be played by local teams almost any day or evening, but games between neighboring towns were generally played on Sunday afternoons, and they provided a social event that was often the entertainment that accompanied a picnic. Church, followed by an activity such as playing or watching baseball, provided relief from the six day a week, 10 plus hours each day work schedule that the men followed; and of course, women often worked more.

Byron, Illinois, the birthplace of A.G. Spalding, was a hotbed of baseball activity both before and after the turn of the 20th century. Traveling to nearby towns, including Rockford, to play their teams, there were many interesting stories that became Byron legends. In 1866 the first baseball club was organized in Byron by N.F. Parsons, "Gat" Stires, B. Osborn, M. Osborn, Dave Spalding (no relation to A.G.) and others. They played only a few games that summer and fall against nearby towns.

They reorganized in 1867 and played their first game against the Rockford Forest City team, and played Rockford again later in the season, losing both games to the Rockford team and its pitcher Al Spalding, a childhood playmate of most of the Byron players. Those were the only games that Byron lost that year. They were said to be "the strongest club to ever carry the Byron colors on the diamond," as they defeated their opponents from the nearby small towns.

Following their last game that season, against the team from the nearby village of Polo, the team claimed the Ogle County championship. They soundly beat Polo by a score of 72 to 22 in a seven inning game, with each Byron player hitting at least one home run. The next season both B. Osborn and "Gat" Stires were playing for Rockford. Byron's best player in 1867, Frank Kindall, was offered a job in Rockford and the opportunity to play for the Forest City Club, but elected to stay in Byron.

It appeared that the criteria prior to 1915 was opponents that could be reached by horseback, wagon, carriage, or cart within a two to three hour period of time, and return within the same

period of time. Of course, after 1915, when more people had automobiles, the distance between towns appeared to be much shorter.

Rockford baseball folklore includes an African American team that played prior to 1872 and was called both the Pink Stockings and the Rockfords. John Molyneaux of the Local History Department of the Rockford Public Library published a book titled *African Americans in Early Rockford, 1834-1870*. Molyneaux's research found references in several local newspapers of the time period 1868-1870, and also found references in the *Chicago Tribune*, the *Chicago Times*, and the *New York City Clipper*.

As hard as he tried to uncover data, Molyneaux's references remain sketchy, although newspaper reports that he found contain bits and pieces, such as "the game of ball between the colored boys of Rockford and Beloit is postponed until Monday." The *Chicago Tribune* reported that "the club are proteges of the Forest City Club." Molyneaux's publication reported that both the *Chicago Times* and the *Chicago Tribune* carried box scores for three games between the Rockford team and the Chicago Blue Stocking team. The Rockford papers described the Rockford team "who played in a uniform made-up of blue cap, white shirt, and blue pants of full length." The papers also said "they wore pink stockings" and gave the Rockford team that name.

In regard to the three games between the Rockford Pink Stockings and the Chicago Blue Stockings, Molyneaux found Chicago newspaper reports that the first game was held at the Winnebago County Fair Grounds, August 1, 1870, and the home team won 27-17 (this was also published in the Rockford newspapers). The second game in the series was reported to have been played at Chicago's Ogden Park, before 400-500 spectators, with the home team winning 48-14. The third game was reported to have been played in Rockford, at the Fairgrounds, with the visitors winning 30-18. According to Molyneaux's findings, the Chicago Times reported that the Chicago Blue Stockings claimed "the colored championship of the state."

Molyneaux hopes that individuals and/or organizations that might have objective information, and perhaps even artifacts about the Rockford Pink Stockings, will come forward and share them with him. That team, and perhaps neighboring African-American teams of the times, may be an important part of Rockford baseball history.

Rockford young men and young women have the opportunity to start playing organized ball in Rockford at a very early age. A variety of introductory experiences are available, including T-Ball. From there they can go to various pee wee leagues, Cub Scout baseball, Boys Club leagues, church leagues, community recreation club programs, and the traditional Little League, Pony League, Colt League, and the traditional American Legion ball progression, together with a variety of other national, state, and local leagues. Unfortunately too many young people do not know that they can enjoy playing baseball without being on an organized team, with uniforms, and several coaches present who may or may not be instructing them in the proper manner. Few kids today go to playgrounds, choose sides, and play ball in the afternoon, when they are out of school. They don't realize that they can do that to hone their skills, and still play on an organized team if they choose.

High school baseball for boys is very popular in Rockford and the surrounding area, with all of the public schools and most of the private schools fielding teams from varsity on down. Rockford high schools and area high schools have, in recent years (and before), advanced at the State level of competition. In Illinois High Schools girls play fast pitch soft ball, and Rockford area high schools play it very competitively. They too have advanced at the State level. Rockford has two colleges, Rockford College and Rock Valley College. Baseball (men) and fast pitch soft ball (women) is played at both schools against other colleges and universities.

Vintage "base ball," modeled after the 19th century game as it was played early in Spalding's era, has seen a resurgence, too, in Rockford. Dave Oberg, Education Resource Manager at the (Rockford) Midway Village & Museum Center, is an enthusiast of old time, vintage baseball, which he describes as being "when men were men and gloves were for sissies." He organized a Midway Village team named the "Midway Marauders," composed of interested local players

who take on other teams such as the Creston Regulators, the Rock Springs Ground Squirrels, and the Cowboys. Before the 2003 season began eight games had been scheduled, and it was anticipated that more would be added as the season progressed. The games are played using 1860 rules and the only equipment allowed is a bat and a ball.

The Marauders" wear resplendent vintage appearing uniforms that were sewn by the Museum seamstress, and the other teams dress in a similar manner, appropriate to the times.

The City of Rockford and the surrounding area is filled with baseball and softball diamonds and several complete sports complexes where both scheduled games and complete tournaments are held throughout the summer. During the season teams from all over the country descend upon Rockford.

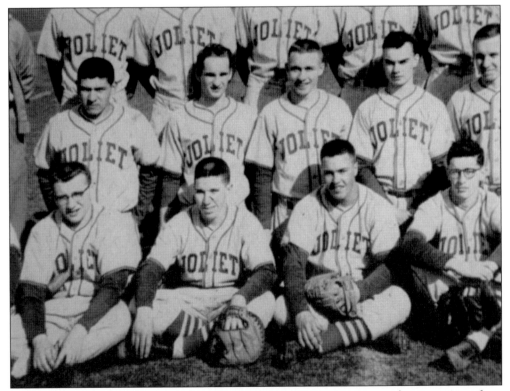

Rockford teams, at various levels, have for more than 100 years competed against teams from neighboring towns and teams from towns some distance away, including Joliet, Illinois, whose championship teams over the years have been memorable.

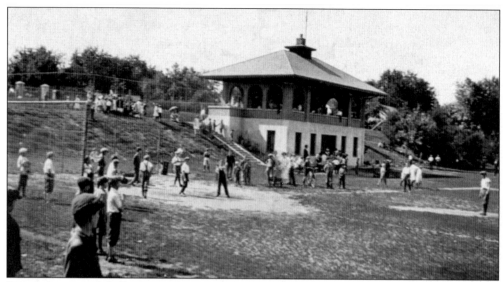

Pictured is a youth ball game at Beattie Park, c. 1900. In comparison to other cities of its size, and even cities larger, Rockford's baseball history, encompassing almost 140 years, is outstanding! The game has been played and enjoyed by countless residents and others who came here to play. In turn, it has been enjoyed by many thousands of spectators, too numerous to even begin to estimate their numbers. (Courtesy of the Rockford Park District.)

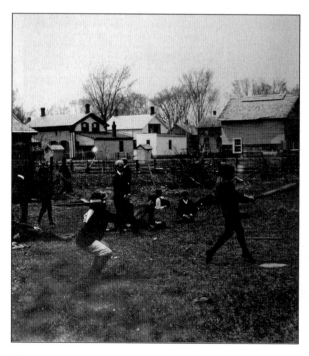

Generations of young boys would follow in Spalding's footsteps and take to the same ball diamonds that the future Hall of Famer used to perfect his game. (Courtesy of the Spalding Commission, Byron Public Library).

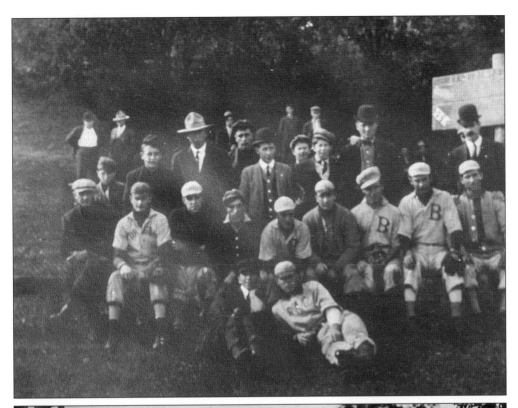

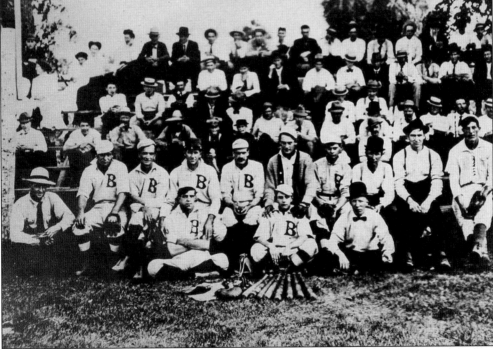

These Rockford region amateur clubs pose in front of their many fans. (Courtesy of the A.G. Spalding Commission, Byron Library.)

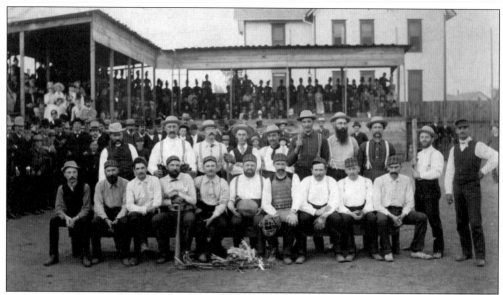

The Rockford community interest in baseball, 1887, is demonstrated by this picture of a benefit held for Rockford Hospital. In an effort to raise money for the hospital, a team of Rockford doctors played a team of Rockford lawyers. The fan support was excellent and a good amount of money was raised by the game, which was won by the doctors, 27-21. Prior to a 2003 game between the Rockford Riverhawks and their scheduled opponents, a team made-up of Rockford lawyers played a team made-up of Rockford doctors, in an attempt to even the score. (Courtesy of Rockford Midway Village and Museum Center.)

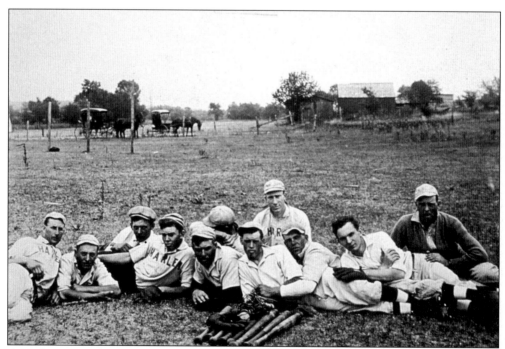

A Harlem Township baseball team poses on the playing field. Note the horses and carriages in the background. (Courtesy of Rockford Midway Village and Museum Center.)

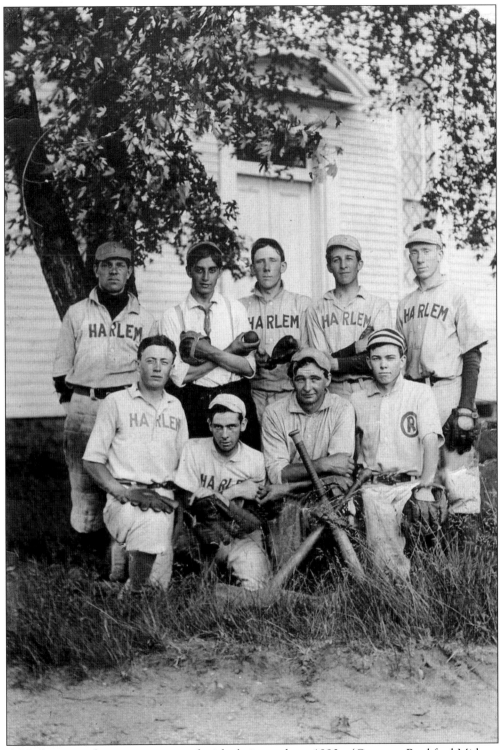

A Harlem township team is pictured with their coach, *c.* 1990s. (Courtesy Rockford Midway Village and Museum Center.)

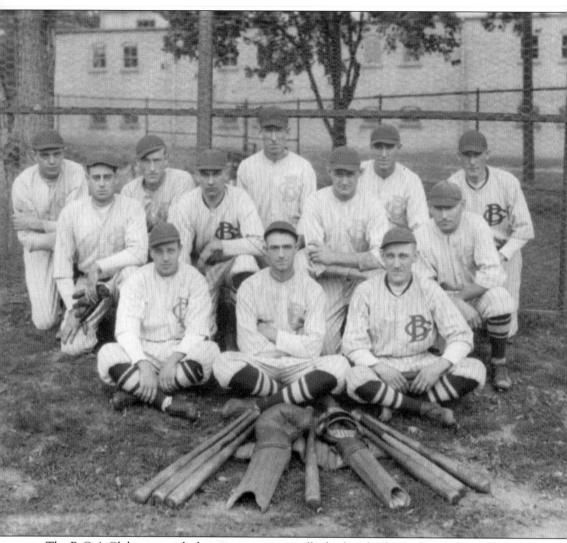

The B-C-A Club poses with their equipment proudly displayed. The Barber-Colman-Company is still a large manufacturing company in the Rockford area and still sponsors employee teams that play teams from other companies, but with no where near the level of play that was common throughout the early 1900s through the 1950s. When games in the "old industrial league" were played many spectators attended, and stories about the games were carried in the local newspapers and company publications. Some companies hired a few employees based upon their baseball skills, and a common quote among the players was "if you make a few errors you might get fired." Currently company sponsored "hard ball" has been replaced by slow pitch softball, and the experience is largely social. (Courtesy of Rockford Midway Village and Museum Center.)

The *B-C-A News*, published for the employees of the Barber-Colman-Company in 1922 illustrates the attention given to Company baseball team. Many local companies competed in the "industrial leagues." (Courtesy of Rockford Midway Village and Museum Center.)

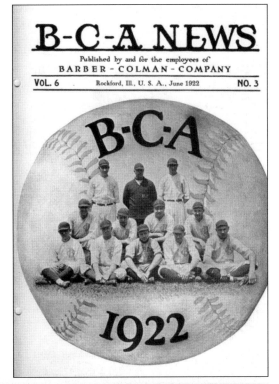

A Barber-Colman-Company baseball team, *c.* 1917–1920. (Courtesy of Rockford Midway Village and Museum Center.)

An unidentified Rockford baseball team. (Courtesy of Rockford Midway Village and Museum Center.)

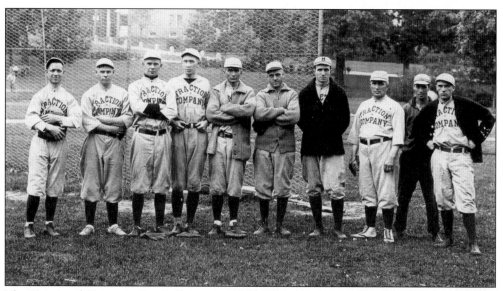

The Tractional Company Baseball team, *c.* 1917-1920. (Courtesy of Rockford Midway Village and Museum Center.)

Opposite, top: A team designated as The Rockford Gophers, *c.* 1912-1915. (Courtesy of Rockford Midway Village and Museum Center.)

Opposite, bottom: A Rockford High School Baseball team, *c.* 1904. Rockford then had only one high school and some years did, and some years didn't, field a team. (Courtesy of Rockford Midway Village and Museum Center.)

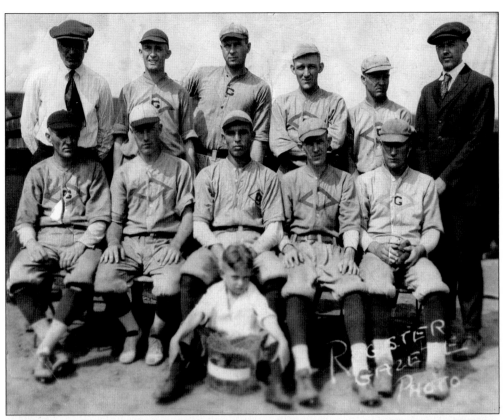

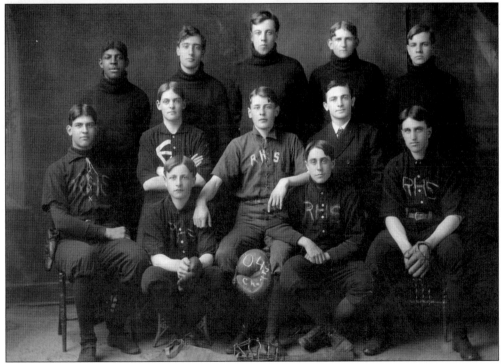

An 1880s Byron team had their picture taken on a wagon. Although unidentified, we know that they are not players from the 1867 Ogle County Champions (pictured on page 51) because gloves can be seen in the picture, and most players didn't start wearing gloves until the 1880s, when the promotions of Spalding & Bros. Sporting Goods Company made such equipment more popular.

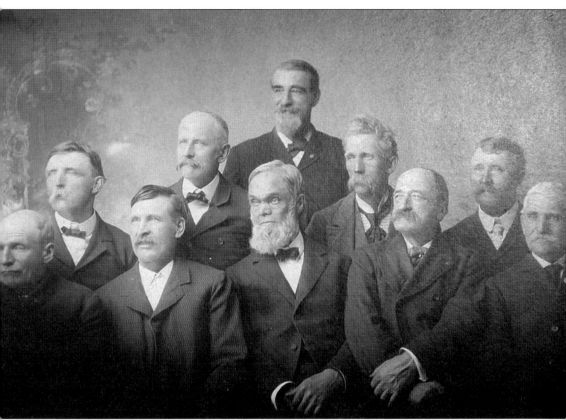

Byron's 1867 Ogle County Champions are a part of local history, and they gathered together 37 years later, in 1904. From left to right are: (front row) J. Faulkner (shortstop), M. Osborn (left field), N.F. Parsons (second base), E.A. Irvine (first base), and E.H. Evans (substitute); (back row) B.Osborn (pitcher), C.A. Sensor (center field), J.H. Hunt (right field), Frank Kendall (third base), and G. Stires (catcher). A few of the old teammates discovered in the spring of 1904 that all of the former members were still alive, and living within 15 miles of Byron. They planned a reunion to be held at the Woodman Hall in Byron, to be followed by an "elegant lunch at the Commercial Hotel." All of the members were able to attend except Will Mix, and the result of that reunion is the above picture, taken for posterity.

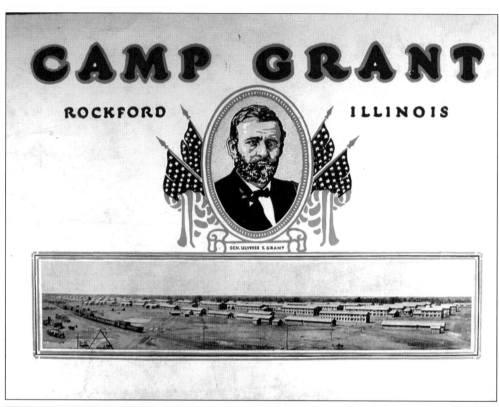

Soldiers stationed at Camp Grant during World War I play ball.

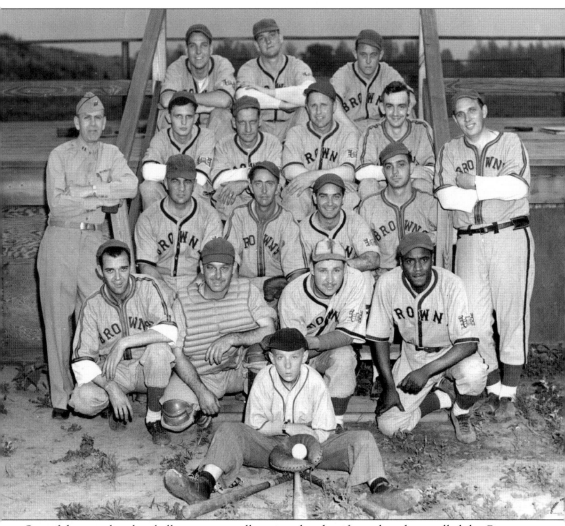

One of the traveling baseball teams was well equipped and uniformed, and was called the Camp Grant Brown Baseball Team for reasons not identified. Captain Gil Johnson was apparently the coach of the Camp Grant "competitive" baseball teams. The Camp was one of the largest military posts just prior to World War II. It fielded "varsity teams" in a variety of competitive sports including football, basketball, boxing and of course, baseball, that competed against other established teams. Records are sketchy, but it has been indicated that the 1941 varsity baseball team had a 31-5 record, and the 1942 team had a 48-13 record including an exhibition game win over the Chicago Cubs. They also played the Chicago White Sox and some minor league teams. Sketchy records mention a 1943 record of 44-12 that included wins over several major league teams in exhibition games, and losses to both the Chicago Cubs and Chicago White Sox. (Courtesy of Rockford Midway Village and Museum Center)

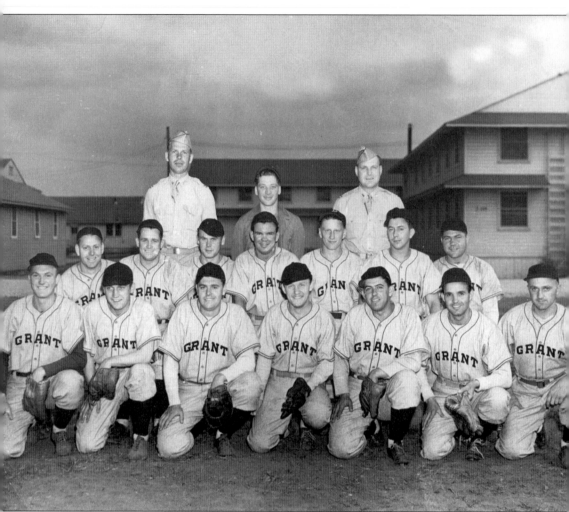

Another traveling team was called the Grant Baseball Team, for obvious reasons. It too was well equipped and uniformed. Like other teams on other military posts during World War II, the teams representing Camp Grant were often made-up of players who had some professional baseball experience, including major league experience. (Courtesy of Rockford Midway Village and Museum Center.)

A Camp Grant, U.S. Army Military Officer is playing baseball during his recreation time. At the height of World War II, the Camp had as many as 50,000 men and women housed there. Recognizing the moral value of both baseball and softball, they had teams within the Camp that played each other, and they also had several teams that traveled, playing college teams, professional ballclubs (including exhibitions against major league and minor league teams), and other military teams from other posts. (Courtesy of Rockford Midway Village and Museum Center.)

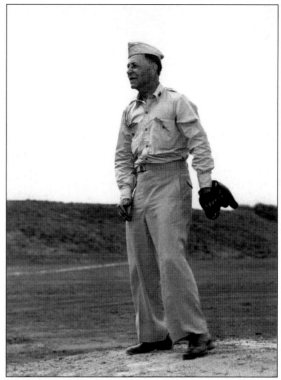

Notice the mitt placed on home plate.

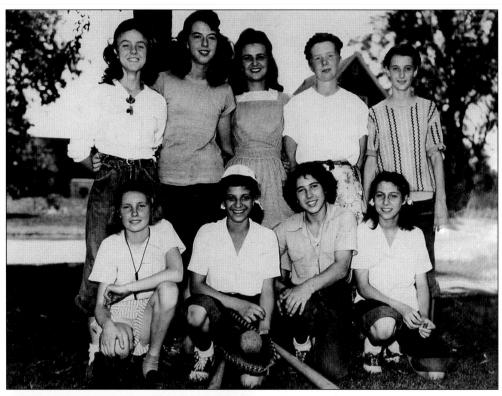

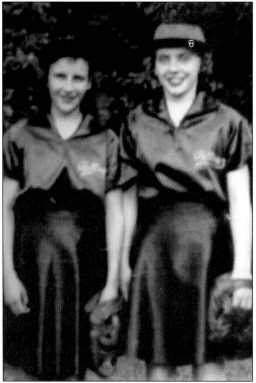

Not all teams were composed of men; women, too, were actively playing ball in Rockford. This team, representing Southeast End Park, won the Women's Park District Championship in 1947. From left to right: (front row) June Gustafson, Angie Sciortino, Ida Prezioso, and Sue Sciortino; (back row) Shirley Sutherland, Barbara Atkins, Coach Phyllis Johnson, N. Lauglery, and Doris Calacurcio. Several of these girls went on to play professionally. (Courtesy of Doris Calacurcio Johnson.)

Like other teams in other area towns, young ladies were playing competitive baseball. These two young ladies, sisters Nellene and Shirley Morrison, played for the Bittner Bakery team, Byron, in the late 1940s. Note the Blouse and skirt uniform, copied from the Rockford Peaches. Neleen Jeter recalls traveling to Rockford to practice with the Peaches, and sometimes played games with other teams before a scheduled Peaches game. (Courtesy of A.G. Spalding Commission and Byron Public Library.)

THREE
Rockford Peaches

This chapter is dedicated to the memory of Dorothy B. Ferguson Key who passed away on May 8, 2003, in Rockford, as this chapter was being written. A member of the Rockford Peaches from 1945 to 1954, she was a stellar performer on the field and a leading contributor to the Peaches success in winning League championships in 1945, 1948, 1949 and 1950. "Dottie" Key "was a lifelong promoter and goodwill ambassador of Women's and Girl's Baseball in North America." She had a positive influence on many thousands of individuals, both young and old.

THIS NARRATIVE ABOUT THE Rockford Peaches does not primarily concern won-loss records of the team or the statistics of individual players, but rather the manner in which women were given the opportunity to compete, amongst themselves, in a game that had

similarities to the men's game of baseball. It provided these women players with the opportunity to be professional athletes. That the money necessary to meet the teams financial obligations was supplied by spectators who enjoyed their style of play, and who were willing to pay for a ticket to watch them compete, is a compliment to the girls' talent and dedication. Most important, the intent of this chapter is to look at the "experiment" as it developed, to include the social and mental aspects of being a member of a professional team, and being given the opportunity to make friendships that in many cases lasted a lifetime. The players were required to adapt to the personal lifestyle required by the league, to live in an environment many miles from where they grew up, and in some cases to train within a foreign culture that could feel threatening. It is essentially a story about a team, the Rockford Peaches, and some of the players that made-up that team during the period of 1943-1948.

It is important to note that much of the information about the Peaches players and manager was provided by the bat girl (1944-1947), Doris Calacurcio, a young amateur player of note, and a keen observer of the team, who were playing the game at the level that she hoped to be playing it when she grew older and developed her playing skills further. It is also seen through the eyes of her older sister, Aldine, a member of the 1947 Peaches team.

When it appeared in late 1942 that the major league season might be canceled until the end of World War II, Philip Wrigley, President of the Chicago Cubs, felt that he and the other owners should look into alternative methods for keeping fans interested in baseball. In addition, to support the war effort, women were now being encouraged to do jobs in business and industry that had been traditionally reserved for men, so why not follow the same patriotic theme in sports, and especially in baseball?

Wrigley, recognizing that what he was proposing was a social as well as business experiment, chose four medium sized midwest cities, all close to Chicago, to make-up the league for the first season, 1943. Supporters in each of the four cities were sold a franchise for $22,500, and promised that they were not only showing their patriotism, they were providing wholesome entertainment for war industry workers and their families.

Being aware of the many female softball leagues that were popular in both the United States and Canada, Wrigley's associates scouted both known players and unknown players, and invited selected women to play in this new league. These selected women were not only excellent players, they were to represent "femininity and high moral standing." In Wrigley's mind these "ladies" were to play ball with the skill of a man, but they were at all times to look and act like a woman. To insure this they were to dress like a lady both on and off the field, wear appropriate make-up and hair styles, demonstrate feminine manners at all times, and follow the social rules set down by the organization, their manager, and most importantly their chaperone, who would be their confidant, their counselor, and the one who would or would not grant them permission to do things that young females might want to do.

The All American Girls Softball League was born and the Racine Belles, the Kenosha Comets, the South Bend Blue Sox, and the Rockford Peaches began play in the late spring of 1943. Although many local women tried out for the Peaches, "Berry" Melin was one of only four area ladies that made the team during the 12 years of the leagues existence—"Berry" Melin, Jean Cione, Aldine Calacurcio, and Barbara Thompson.

In the spring of 1947 Aldine Calacurcio, then 18, began the adventure of her lifetime. After graduating from Rockford East High School with the class of 1946, Aldine was working at the J.L. Clark Manufacturing Company in Rockford and playing shortstop for their girls softball team that competed in the Rockford Women's Industrial League. Living near Beyer Stadium where the Rockford Peaches had played the previous four seasons, Aldine frequently worked out with the Peaches, and caught the baseball eye of its manager, Bill Allington, as he observed her in those practices. He also went to girls industrial league games and watched Aldine and others play, and was apparently impressed with her talents.

Early in the spring of 1947 Aldine was surprised to receive a telegram from the All American Girls baseball League office stating that she would be offered a contract to play for the Rockford

Peaches that season (1947). This news was quickly picked-up by the Rockford newspapers, which referred to Aldine as a "Homegrown Peach" in one of their headlines. This correspondence, and the several that followed it, directed her to quit her job at J.L. Clark, pack a suitcase, and board a plane in Chicago, together with her Peaches teammates, and the other teams in the League. They were all flying to Havana, Cuba for spring training, about 175 players from the Rockford, Kenosha, Racine, Fort Wayne, South Bend, Muskegon, Peoria, and Grand Rapids teams.

May 1, 1947 posed a problem. That date was, and still is, "International Worker's Day," a revolutionary day that could get out of hand. The girls were instructed by armed soldiers who were to serve as guards, to not only stay within the hotel that day, but to stay on their floors and in their rooms. Aldine remembers lowering by rope the baskets that were provided and pulling back up to their floors the food and drinks that had been placed in them.

Following that unique spring training experience, Aldine made the Peaches team and played during the 1947 season. She recalls that most of her playing time as a utility shortstop, and at other positions as needed, was during away games. The manager was being very careful not to allow her to be embarrassed by an error or other mistake in front of her hometown crowd.

Prior to the 1948 season Aldine was again offered a contract by the Peaches, but she gave into her boyfriend who wanted to get married. She went back to her job at the J.L. Clark Company, and inquired about playing on its industrial league team, but only for home games. Her husband didn't want her to travel out-of-town with the team. The company did not allow that, nor did the Warner Lambert Company for whom she later worked. Aldine's professional baseball career consisted of only one season, but what an adventure to be remembered for a lifetime.

Aldines's younger sister, Doris, who served four years as the Peaches' bat girl, was also on track to make the team. During post practice instruction sessions Doris had demonstrated that she not only had potential as a player, but she also demonstrated that she had the desire to be a successful player. Then, and during the following years, Doris played on several local girls softball teams and performed very well.

Prior to the 1948 season, when Doris Calacurcio was 16 years old, a local player of note, a Rockford East High School cheerleader, and preparing to enter her junior year in the fall, Manager Allington arranged for her to play that summer for the Chicago Coeds, one of several minor league teams sponsored by the All American Girls Baseball League. Housing in Chicago was arranged for Doris that summer, and the next, enabling Doris to have two years of professional minor league experience, both of which were with the Chicago Coeds. Her older sister had played the 1947 season with the Rockford Peaches, but by the time Doris was ready for the Peaches the League was folding, because the major leagues were playing quality baseball, the minor leagues were flourishing, people now had more money to do more things, and most of all, on most nights people were "glued" to their television sets. However, the noble experiment of women's professional baseball had been a success.

From time to time vendors will put out a Rockford Peaches collectable and market it in the Rockford area. This is a photo of a "cookie tin" that was sold locally in the 1990s to commemorate a Peaches event. (Courtesy of Doris Calacurcio Johnson.)

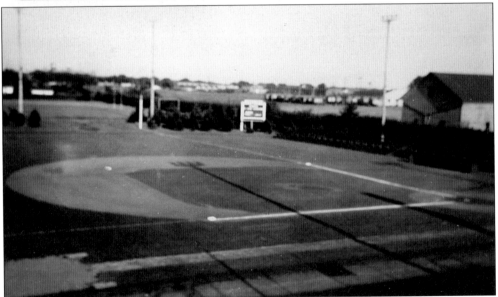

Pictured is the Peaches home field, Beyer Stadium, also known as 15th Avenue Stadium, where both Rockford East and Rockford West High Schools played their home football games in the fall. It became home of the Rockford Peaches from 1943 to 1954. The concrete stands ran the length of the third base side of the field for about 120 yards, and temporary bleachers (that were used during football season) could be installed down the first base line and from far right field to center field. Although the Peaches left after the 1954 season Beyer Stadium was used for high school football until the late 1960s and for other events into the 1990s before it was destroyed to create more athletic fields for Beyer School. (Courtesy of Doris Calacurcio Johnson.)

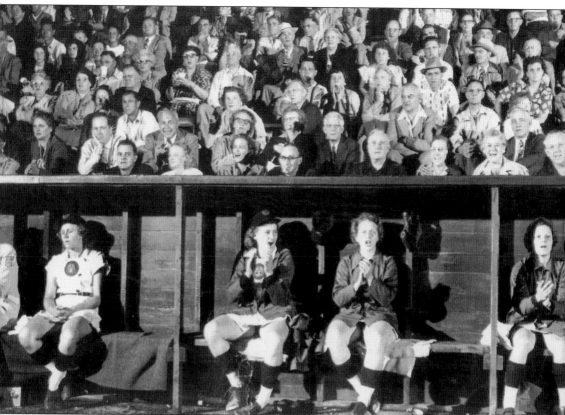

Pictured, from left to right, Dorothy Green (chaperone), unidentified, Lou Ericson, Lois Florriech, and Irene Applegate cheer on their Peaches teammates before a full house at Beyer Stadium.

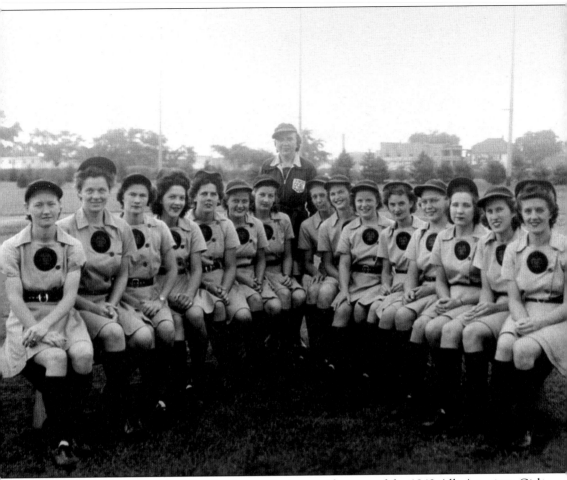

The first crop of Rockford Peaches began the inaugural season of the 1943 All-American Girls Softball League with 15 players who had been scouted and recruited from all over the United States and Canada. Each had, or would soon earn, a nickname (not in the order in which they are seated): Gladys "Terrie" Davies (Toronto, Canada), Millie "Mil" Warwick (Regina, Canada), Irene "Punk" Runkle (Chicago), Helen "Nellie" Nelson (Toronto, Canada), Olive "Ollie" Little (Popular Point, Canada), Marie "Timmey" Timm (West Allis, Wisconsin), Dorothy "Dottie" Green (Natick, Mass.), Muriel "Cabie" Coben (Sasketchewan, Canada), Mary Jo "Pete" Peters, (West Allis, Wisconsin), Eileen "Burmy" Burmeister (Theinsville, Wisconsin), Betty Jo "Fritzie" Fritz (Oshkosh, Wisconsin), Betty Jane "Betty" Moezinski (Milwaukee, Wisconsin), Mary "Prattie" Pratt (Wallston, Mass.), Dorothy "Kamy" Kamenshek (Cinncinati, Ohio) and Berith "Berry" Melin (Rockford, Illinois). (Courtesy of John Melin.)

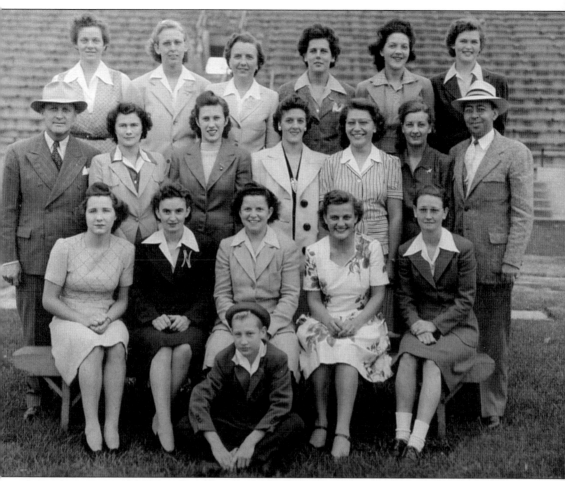

The 1943 team is pictured in their "off-field" clothing. From left to right: (front row) Millie Warwick, Helen Nelson, Mary Pratt, unidentified, and unidentified; (middle row) Eddie Stumpf (Manager), Olive Little, Dorothy Kamenshek, Gladys Davies, Eileen Burmeister, unidentified, and Melvin Shaffer (Business Manager); (back row) Mildred Deegan, Berith Melin, Marie Timm (Chaperone), unknown, Irene Runkle, and Dorothy Green. Bat boy Eddie Otting is sitting up front. (Courtesy of John Melin.)

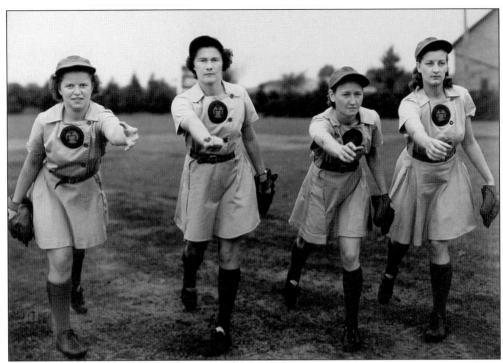

The Peaches 1943 Pitching Staff, from left to right, are Mary Pratt, Olive Little, and two unknown. (Courtesy the Don Melin Collection.)

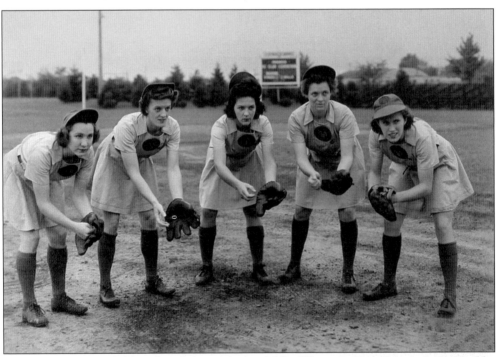

The Peaches 1943 Infielders, from left to right, are Millie Warwick, Terri Davies, Irene Runkle, Millie Deegan, and Dorothy Kamenshek. (Courtesy of the John Melin Collection.)

The Peaches 1943 catchers are Dottie Green (left) and Helen Nelson. (Courtesy of the Don Melin Collection).

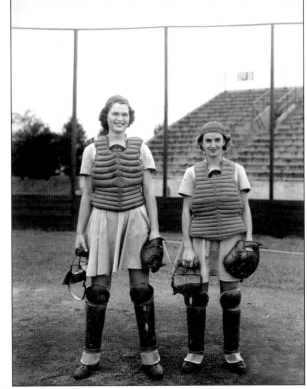

The Peaches 1943 outfielders, from left to right, are Eileen Burmeister, unknown, "Berry" Melin, and unknown. (Courtesy the John Melin Collection.)

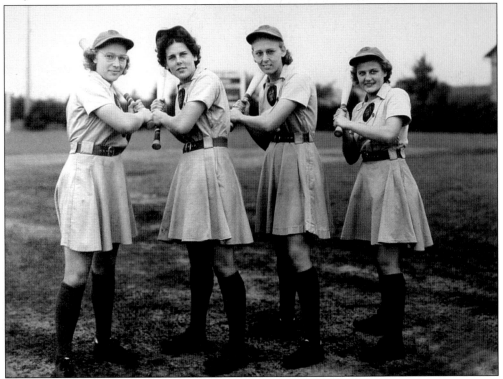

1943 Peaches Manager Eddie Stumpf poses with Marie Timm, the first team chaperone who served during the first three seasons. She was very popular with the Peaches players. (Courtesy of John Melin)

Ken Sells, a Chicago Cubs employee and a protege of Phillip Wrigley, was the first President of the four-team league, in 1943. Sells played an important administrative/business role with the League in the early years, and was the contact between the League and Wrigley, who was the dominant financial sponsor of the League and President of the Chicago Cubs.

In 1943 Berith "Berry" Ahlquist Melin was working at the National Lock, Corporation, Rockford, and playing fast pitch softball for the company sponsored women's team that competed in the Rockford Industrial League. She had earlier in her career played for the Peter Shoe Company team. Berry saw an announcement that the newly forming All American Girls Softball League would be holding try-outs in Rockford, for their four teams that were to start the season in the very near future. They were especially looking for a few girls for the local team, the Rockford Peaches. The Rockford team had already scouted and signed a number of players from all over this country and Canada. "Berry's" husband was on active duty in the United States Army, having enlisted shortly after Pearl Harbor. This was an opportunity that she could accept at this time of her life, if she made the team. Berry made the Peaches team, and was the starting center fielder during the entire 1943 season. Prior to the 1944 season her husband, Manfred Melin, was honorably discharged from the military (at age 35) and returned to his home in Rockford and his wife Berry. Like many returning veterans, Manfred wanted to settle down and start a family. Consequently, Berry gave-up her baseball career, but kept many fond memories.

Dorothy "Snookie" Harrell was one of the many Peaches who represented what Phillip Wrigley had in mind when he wanted to form a league in which "ladies were to represent femininity, yet play ball with the skills of a man." Although very attractive and petitie, Snookie hit with power and led the team in runs batted in for a number of seasons.

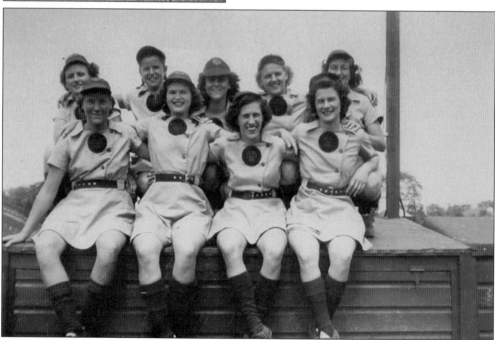

A group of Peaches is seen hanging out on top of the dugout. Up front, from left to right, are Sally Mier, Dorothy Green, Dorothy Kamenshek, and Olive Little. Behind them, from left to right, are unidentified, Mary Pratt, Marge Holgerson, Helen Filarski and Dorothy Ferguson Key.

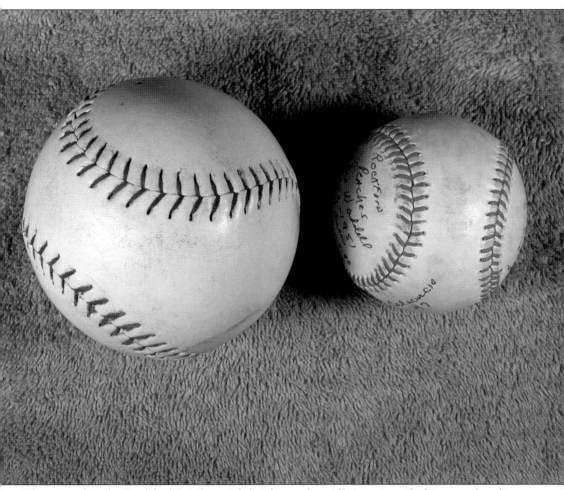

The game that the Rockford Peaches and the three other All-American Girls teams played in 1943 was "soft ball," and not "hard ball," as was inferred by the movie A LEAGUE OF THEIR OWN. The ball had a 12 inch circumference, the length of the base paths was 65 feet, the pitching distance was 40 feet, and the pitching style was underhand. It in no way resembled the men's game of a hard ball of 9 inches circumference, 90 foot base paths, 60 feet, six inch pitching distance, and overhand and sidearm pitching style. Nevertheless, the game as it was played by these All-American Girls was an exciting game that required the finest of skills. A fast paced game, it was well received by the fans who came to watch them play.

By 1948 the circumference of the AAGPL "official" ball was 10 3/8 inches, the length of the base paths was 72 feet, the pitching distance was 50 feet, and the pitching style was overhand and sidearm. During the next six seasons (1949-1954) the game played by the All American Girls Professional Baseball League became more like the game played by men, the ball became smaller, the base paths were increased, as was the pitching distance, but none of the changes in those areas reached the measurements of the men's game. The popularity of the AAGPBL, as measured by attendance at league games started to decline after the 1948 season, but probably for reasons other than rule changes and the quality of the game played by the female players.

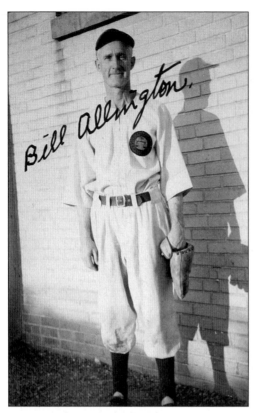

Bill Allington is remembered as a great teacher who loved the game of baseball with a passion. Doris Calacurcio Johnson can still recall his lessons on baseball and life, and recite them word-for-word: "Playing baseball is teaching you how to live life. It teaches you how to follow the rules, it teaches you to work hard, respect others, dedicate yourself to the tasks at hand, and to never quit." (Courtesy of the Doris Calacurcio Johnson Collection.)

Bill Allington, the man selected to manage the Rockford Peaches in 1944, was a solid baseball man, with lots of playing experience, all of which was in the minor leagues. Living in California, Bill had been working full-time for one of the major motion picture studios, and continued to do so during the off-season when he managed in the All-American Girls league. Bill was also familiar with the California girls softball leagues, and personally knew many of their star players, some of whom would later play for him in Rockford, as well for other All-American teams. His love for the game of baseball led him to accept the offer to manage the Rockford Peaches. Not only was he determined to share his knowledge of the game, and the skills required to be a winner with the official members of the Peaches, he made himself available to girls and boys who like to "hang around' when the Peaches were practicing, and after practice he would help these youngsters to develop their own baseball skills and to dream about sometime making it to the "big leagues."

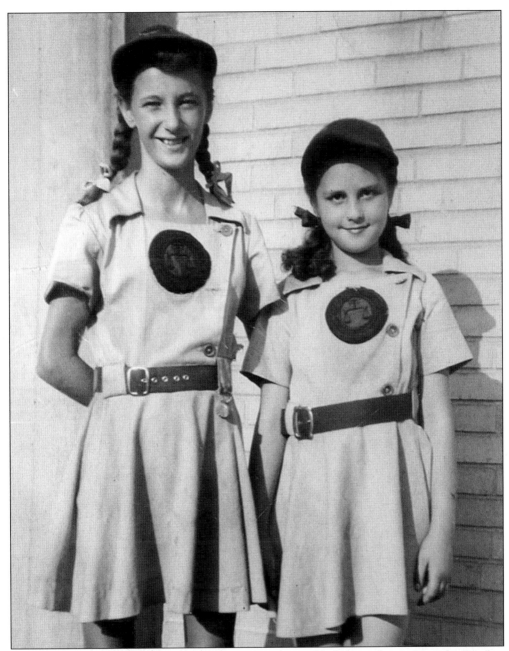

When she was 12 years old, a girl who lived less than a block away from where the Peaches practiced and played their games, and who was a regular at Manager Allington's post practice instruction sessions, and had attended all of the Peaches home games during the previous season (1943), was asked by manager Allington if she and a friend would like to be the "Official Rockford Peaches Bat Girls" for the 1944 season. Bill decided to be the first manager in the league to have "official bat girls," yet keep the bat boy He would see that they both would be given official Rockford Peaches uniforms and would be an important part of the team. Both Doris Calacurcio and her friend Nancy Manne enthusiastically accepted Allington's invitation for each of the next four seasons.

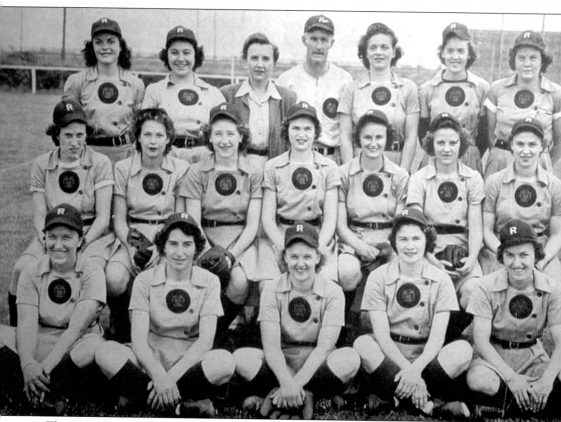

The 1945 Champion Rockford Peaches, from left to right: (front row) Rose Gacioch, Dorothy Ferguson, Helen Filarski, Olive Little, and Josephine Leonard; (middle row) Dorothy Kamenshek, Kay Rohrer, Dorothy Harrell, Dorothy Green, Betty Carveth, Irene Applegreen, and Irene Kotowicz; (back Row) Carolyn Morris, Margaret Wigiser, Marie Timme (Chaperone), Bill Allington (Manager), Mildred Deegan, Alva Jo Fisher, and Jean Cione. The 1945 team was the defining team for the Peaches. Manager Bill Allington now had the team that he selected, with only three players who were on the 1943 ball club—Little, Green, and Kamenshek. He had taught them how to play as he wanted them to play, and the Peaches proved to all that they were the best. They had had the experience of having the time of their lives playing winning baseball. (Courtesy of Doris Calacurcio Johnson.)

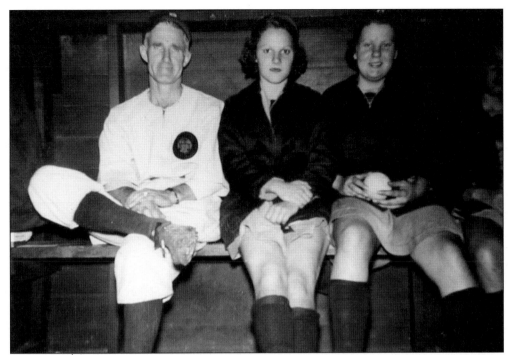

From left to right are Bill Allington, Irene Applegren, and Jean Cione. (Courtesy of Doris Calacurcio Johnson.)

From left to right are Dottie Green, Irene Kotowicz, Olive Little, and Alva Jo Fisher. (Courtesy of Doris Calacurcio Johnson.)

From left to right are Millie Deegan, Jo Leonard, Dottie Green, Kay Rohrer, and Carolyn Morris. (Courtesy of Doris Calacurcio Johnson.).

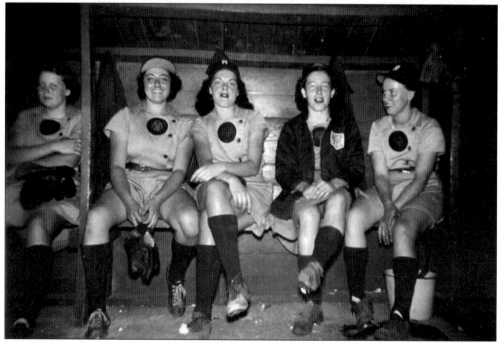

From left to right are Jean Cione, Marge Wigiser, Carolyn Morris, Dorothy Harrell, and Irene Kotowicz. (Courtesy of Doris Calacurcio Johnson.)

Winning the 1945 League Championship was an exciting event and called for a celebration. Celebrating, from left to right, are Manager Bill Allington, Dorothy Kamenshek, Chaperone Millie Timm, Nancy Manne, Millie Deegan, Doris Calacurcio, and Dorothy Green (holding the flowers). (Courtesy of Doris Calacurcio Johnson.)

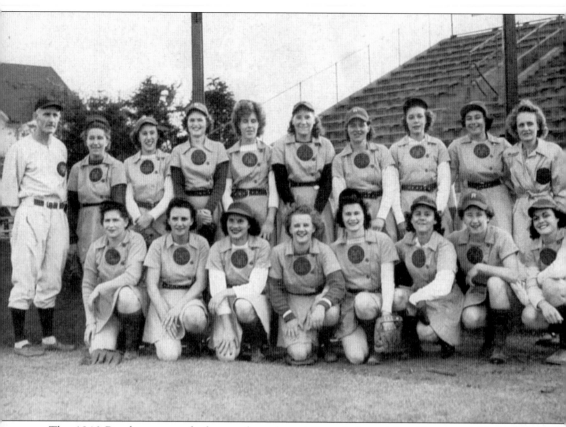

The 1946 Peaches are ready for another season! From left to right: (front row) Betty Yahr, Dorothy Cook, Lee Surkowski, Helen Filarski, Olive Little, Marge Holgerson, Dorothy Harrell, and Carolyn Morris; (back row) Bill Allington (manager), Rose Gacioch, Dorothy Kamenshek, Dorothy Green, Dorothy Moon, Naoimi Meier, Mildred Deegan, Helen Smith, Marge Wigiser, and Mildred Lundahl (chaperone). Yes, that's five Dorothies on one ball club.

Lee Surkowski, Helen Filarski, and Millie Deegan remind fans what season it is.

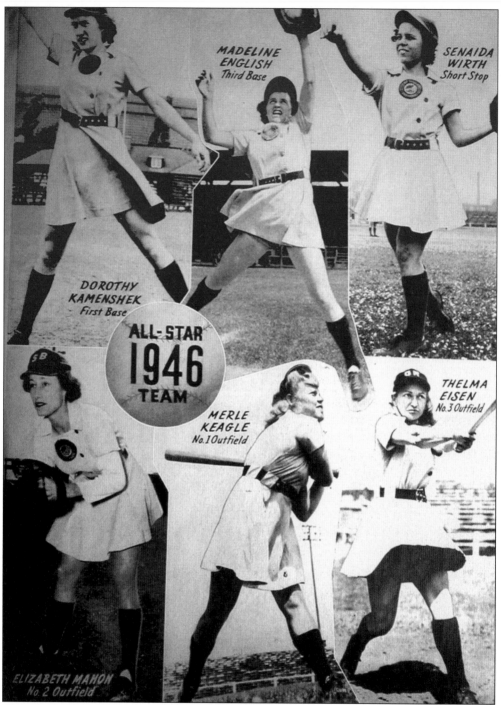

This AAPGBBL collector's program captures the league's all-stars in action, including Rockford Peaches first base star Dorothy Kamenshek (upper left). Kamenshek led the league in hitting with a .319 batting average while posting a solid .985 fielding percentage (3rd in league) and stealing 109 bases (5th in league) in 107 games.

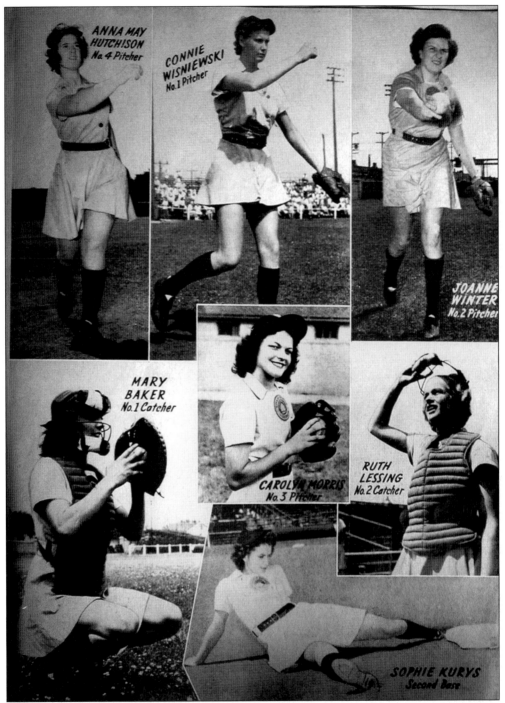

Rockford ace Carolyn Morris (center) joined Dorothy on the 1946 All-Star Team. Morris' greatest day as a Peach was July 6, 1945, when she tossed a nine-inning perfect game against Fort Wayne.

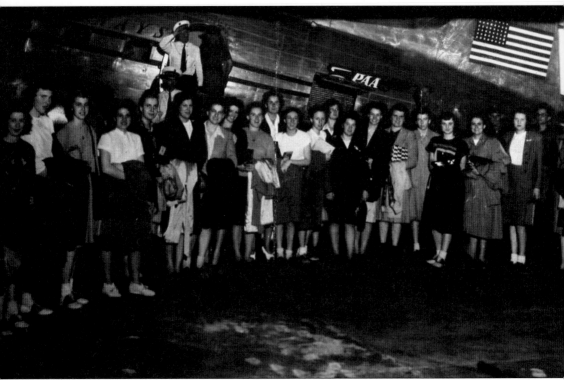

Aldine Calacurcio is the fourth from the right in the front row. Her Peaches teammate and friend Jean Cione, also from Rockford, is second from the right. Arriving in Cuba, the players were bused to the Seville Biltmore Hotel in downtown Havana, which would be their home for the next several weeks. The ladies were lectured about maintaining appropriate behavior, and warned about the Cuban men. The sidewalks below were often filled with Cuban men who whistled and yelled to them every time the Peaches showed themselves on their balconies (which was often). Every day their assigned driver drove the team bus to the university or to the stadium for their practice sessions. Everyday it was a new adventure. The Cuban drivers were very aggressive, and honking horns and drivers yelling was the norm in Havana. She also has remembered the bus rides through the neighborhoods and the contrast between oppulence in some and the extreme poverty in others. The rebellion against the Cuban Dictator, Battista, had started, and would go on for another 12 years.

Rockford Peach Millie Deegan, shown here in Havana, Cuba, played second base until after the 1948 season, when pitching overhand would be allowed. She then became a successful pitcher.

Two unidentified members of the Fort Wayne Daisies arrive for spring training in Havana.

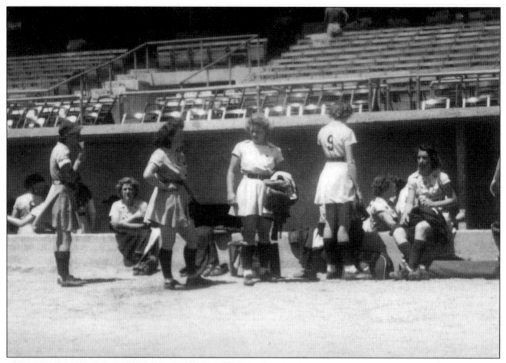

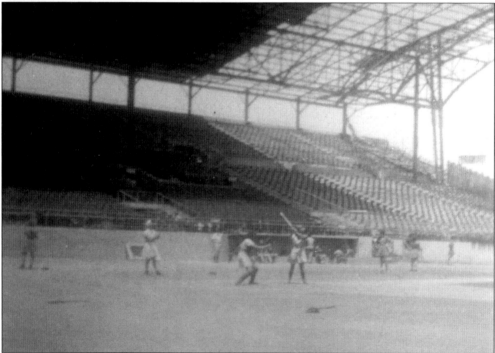

Some practices were held, and most games were played at the "Gran Stadium de Havana." Aldine remembers attendance at some games exceeding 15,000. She reported that the Cuban men flocked to the games, mostly in white suits, and showed appreciation for a good play by whistling and making kissing noises.

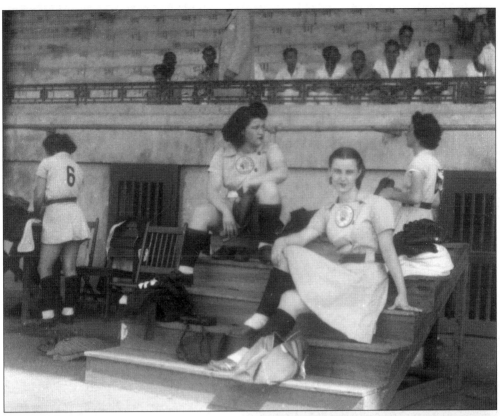

Aldine Calacuricio poses in front of her teammates at the Gran Stadium. Note the admiring Cuban men in the background. (Courtesy of Doris Calacurcio Johnson)

An unidentified Peach gathers her equipment in the dugout in Havana. (Courtesy of Doris Calacurcio Johnson)

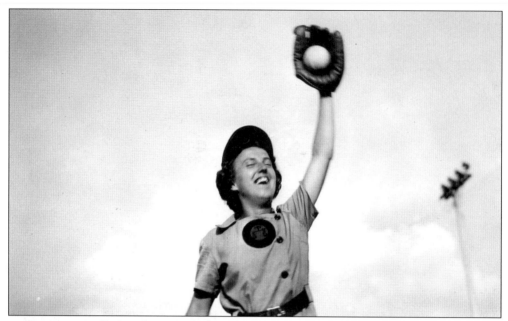

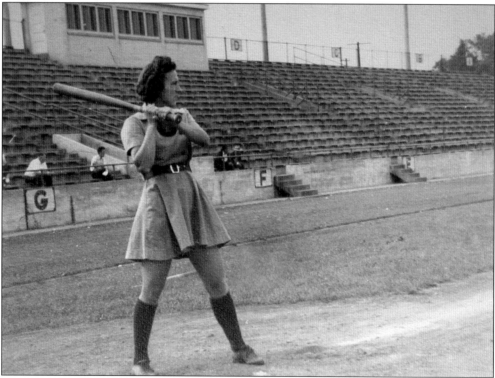

Josephine "Jo" Lenard was one of the most popular players, both with the other players and the fans. She always was chewing several sticks of her favorite gum, Wrigley's Spearmint, and consequently appreciative fans always gave her gum both before and after games. Doris remembers that her locker was so full of gum that she always shared it with others. (All courtesy of Doris Calacurcio Johnson).

Millie Warwick (top) and Margaret Jones (bottom) were both good players and good friends to all of the team. Both were from Regina, Canada, and gave the team an international flavor. (Courtesy of Doris Calacurcio Johnson).

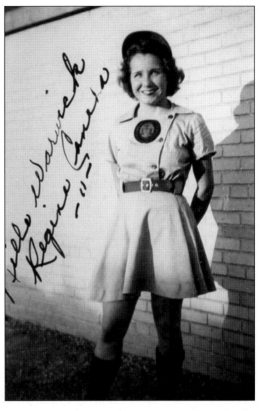

Dodie Nelson and many of the other Peaches appreciated Manager Bill Allington's position that they could be almost as casual as they wanted to be in practice, as long as they practiced with both skill and intensity. However, during every game every player must be dressed in the official Peaches uniform and no modifications were allowed. Here, Dodie is in seen in game uniform (top) and practice attire (bottom). (Courtesy of Doris Calacurcio Johnson)

Kay Rohrer, a catcher, was from California and spent the off-seasons playing "bit parts" in movies. She would follow the Rockford newspapers, and when one of "her pictures" was in town she would invite her teammates to come and see her act. In turn, both while and after seeing Kay's movies, they would "razz" her about the only a few seconds that she was on the screen. Manager Bill Allington worked full-time for 20th Century Fox Studios for many years during the off-season. (Courtesy of Doris Calacurcio Johnson).

Marge Stefani, second baseman, loved to drink Coca Cola when not on the field. Doris remembers that fans enjoyed giving her bottles of "Coke" both before and after games. (Courtesy of Doris Calacurcio Johnson).

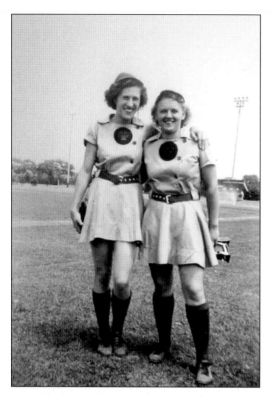

Dorothy "Kammey" Kamenshek (left) was one of the most respected and most popular Peaches. She was a good friend to all, an outstanding player in the clutch, and was perennially named to the League All Star Team. She was a Rockford Peach for all 12 years of the teams existence. Among Kammey's many close friends was infielder Helen Filarski (right). Dorothy's closest friend was her mother, who raised her as a single parent. "Kammey" was nine years old when her father passed away. Kammey's mother often came from Cincinnati to see her play and the other players just loved her. (Courtesy of Doris Calacurcio Johnson)

Doris Calacurcio took a very positive approach to learning how to play most of the positions on a team, even pitching. Bill Allington, the Peaches Manager, and many of the Peaches players helped her. Scrapbooks that her mother kept on her softball/baseball activities validate that she was a very promising player. (Courtesy of Doris Calacurcio Johnson.)

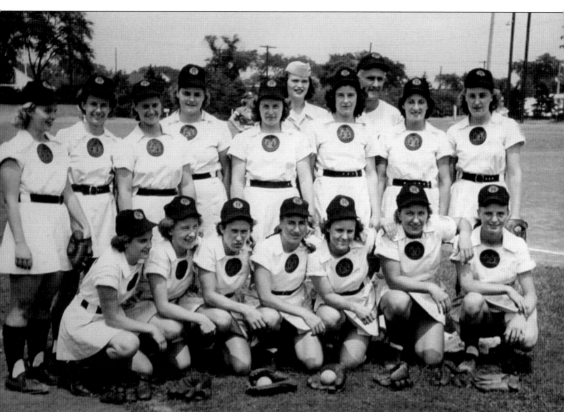

In 1948 the Rockford Peaches were again the League Champions, but without Doris and Aldine. Aldine was now married and back working at her job at J.L. Clark Corporation, and Doris was playing baseball in Chicago for a sanctioned minor league team, although she couldn't play for the Peaches until she graduated from high school in 1950, and by then, her opportunities were different. Reflecting upon her experiences, both with the Peaches, and on the other teams for which she was an active player, Doris Calacurcio Johnson said: "Because of Bill Allington, all of the Rockford Peaches, and the other players on teams that I was apart of, I will cherish those wonderful memories forever. It was an honor and privilege to have played baseball."

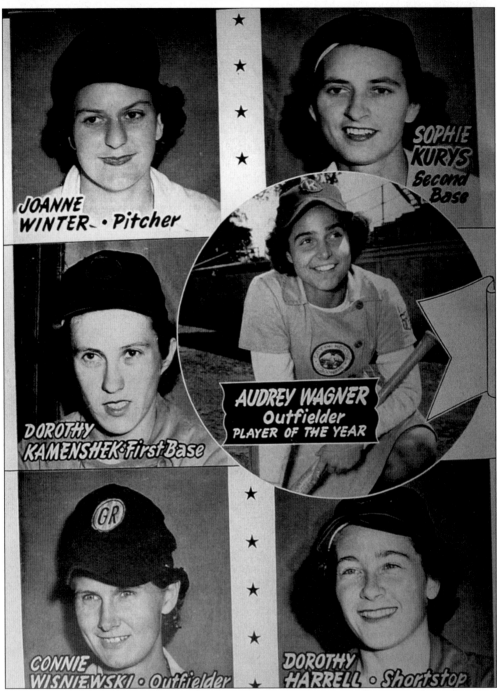

Peaches shortstop Dorothy Harrell (bottom right) joined Kammy (left center) on the 1948 League All-Star Team.

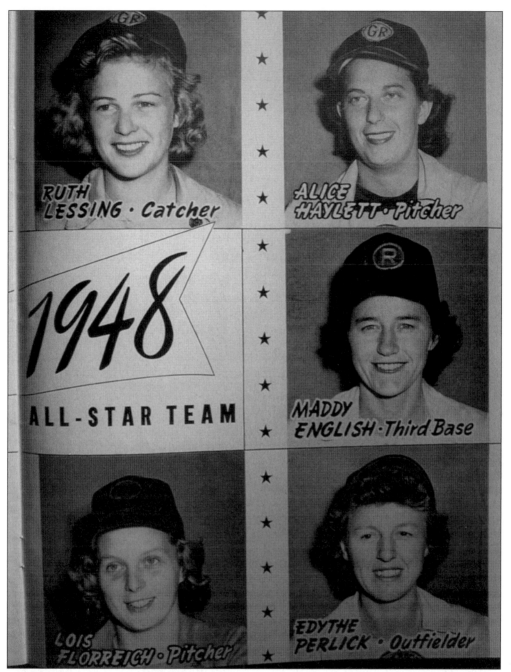

RUTH LESSING · Catcher

ALICE HAYLETT · Pitcher

1948 ALL-STAR TEAM

MADDY ENGLISH · Third Base

LOIS FLORREICH · Pitcher

EDYTHE PERLICK · Outfielder

Peaches pitching star Lois Florreich (bottom left), too, was counted among the league's best that season.

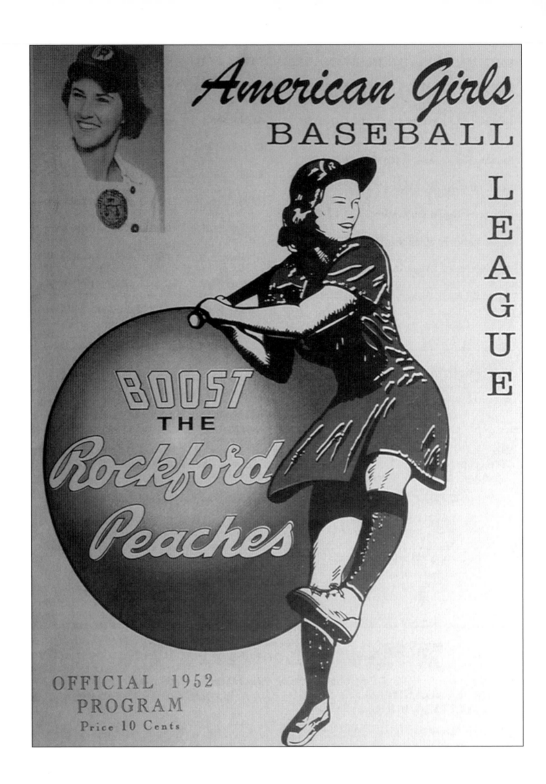

American Girls
BASEBALL
LEAGUE

BOOST
THE
Rockford
Peaches

OFFICIAL 1952
PROGRAM
Price 10 Cents

FOUR

Men's Professional Baseball in Rockford

ORGANIZED MEN'S PROFESSIONAL BASEBALL officially began in Rockford with the 1871 Rockford Forest City Baseball Club that played in the first major league, the National Association. After the demise of that major league team following the 1871 season, various Rockford teams continued to play teams from other communities, with some monetary support that was typically "pass the hat for the payers," or being paid by a business or industry by whom they were employed. Between 1879 and 1923 Rockford was the home of eight different professional minor league organizations, and fourteen different teams within those leagues.

In 1879, Rockford again had a professional team that was part of the Northwestern League, which had the distinction of being recognized as the first "minor league" in organized baseball. The four-team league was represented by Omaha, Dubuque, and Davenport in addition to Rockford, but refused to affiliate with either the National Association or the National League. The owners settled for limited attendance while setting salary standards, thinking this would be a profitable combination, but the league folded after its first season. The Northwestern League would be reborn in 1883, this time signing a 'tripartite agreement' with the NA and NL and serving as more of an official minor league, but without a Rockford franchise.

Rockford was again without a professional team until 1888, when the town entered the Central Inter-State Professional League. The Rockford team played their games in a newly constructed ballpark on the west side of the river named Camp Grounds Park. The team lasted only six weeks, however, going 11-23 before disbanding in late June. It was quite common for teams to fold mid-season during this era.

In 1891 a new team was formed and a franchise was obtained in the unaffiliated Illinois-Iowa League. The Rockford Hustlers (pictured on page 7), with manager Hugh Nicol moved to the eight-team Illinois-Indiana League the following year, posting a second best overall record of 46-38 but failing to win either half of the split season. That 1892 club's offense was led by league leaders in batting average (Fred Underwood, .282), runs scored (Ed Wiswell, 77), and home runs (Charles Thorpe, 9). Hugh's son, George Nicole, pitched for the Hustlers and led the league with 230 strikeouts. Eighteen ninety-two was the final season for the Rockford Hustlers, as the Two-I League would fold before the next season could begin. This notable club was followed by several Rockford teams in three separate leagues (Western Association, Three-I, and Wisconsin-Illinois) from 1895 to 1923. It was not an era of great stability.

From 1924 to 1943 Rockford was without a professional baseball team. As discussed in Chapter Three, for the next 12 seasons (1943-1954), The Rockford Peaches provided spectators with quality softball/baseball, until the league folded. While the women's team, the Peaches, was still active, a men's professional team also played in Rockford, from 1947 to 1949.

The Rockford Rox, a Class C minor league team of the Cincinnati Reds, played in the six-team Central Association. Despite going 68-57 and setting a league high attendance of 67,938 in the inaugural '47 season, both their performance and their fan base would sink in '48 and '49. The Rox simply could not draw as many fans as the Peaches, and they disbanded after the 1949 season. It was almost 40 years until Rockford had another men's professional team.

Professional baseball returned to Rockford again in 1988 When the Montreal Expos placed their Midwest League Class A team in the City. The games were played in a carefully remodeled Marinelli Stadium, and the fan support was reasonably good. The Expos departed after the 1992 season, and were replaced by a Kansas City Royals team that played in Rockford in 1993 and 1994. Rockford was excited when the Chicago Cubs organization brought their Cubbies team to town, and played at Marinelli Stadium from 1995 through 1998. Their place was taken by the Cincinnati Reds brought their Midwest League Class A team to town with the understanding that it would be for only one season. As discussed in the introductory chapter Rockford fans supported the teams, but Major League operated Minor League baseball had become big business and other cities were openly competing for the teams. An official major league baseball publication, *2003 Who's Who in Baseball*, lists a number of players who played in Rockford and are still active players in the Major Leagues.

After two years without professional baseball, the second largest city in the state is currently the home of the Rockford RiverHawks, a team in the Frontier League of Professional Baseball. The Frontier League is made-up of two divisions, with six teams in each division. In the East Division are the Chillicothe Paints, the Evansville Otters, the Florence Freedom, the Kalamazoo Kings, the Richmond Roosters, and the Washington Wild Things. In the West Division are the Cook County Cheetahs, the Gateway Grizzlies, the Kenosha Mammoths, the Mid-Missouri Mavericks, the River City Rascals, and the Rockford RiverHawks. The RiverHawks nearest opponent is (Kenosha) is 82 miles away, and its furthermost opponent (Washington, PA) is 577 miles away.

The Frontier League is a professional baseball league made-up of mature professional players who are older than many minor players, but have not reached age 27 by the start of the season. Many hope to sign with a Major League organization when their talents are again recognized. Eight of the current Rockford RiverHawks, and many current players on opposing teams, have already been a part of a Major League organization.

The 2003 *Frontier League Record Book and Directory* lists well over 200 "Former Frontier League players signed and released by major league organizations over the previous 11 seasons." In addition, it lists 48 "Frontier League Alumni" currently playing for Major League organizations, including three who were currently on major league teams. The *Directory* also cites 22 managers, coaches, office personnel, and umpires currently active in major league organizations (2003), who were formerly involved with Frontier League teams.

The community is made aware that the players are quality young men, adults above 21 years of age, and almost all have attended college. They are playing baseball because they love the game, and some are following their dream of becoming a major league player, with this opportunity of showing their skills in the Frontier League. Some former players have made it to the majors by following this route.

Although they are professional baseball players, they are not highly paid. Many make less than $1,000 a month during the season. The clubs management team helps players to find satisfactory housing that may include living with a host family. One host "mom" described the experience as "providing nothing more than a spare bed and a good heart." Host situations can and do differ. Some hosted players eat with the family and others don't. Some hosted players help around the house and yard, while others are just a live-in guest. Of course, if the hosted player wants to play catch with the family's kids, that is a real plus for the host family.

Prior to the start of the RiverHawks' 2003 season twelve families had volunteered to host a player(s). The team's management rewarded each of them with a season pass for all members of the family, invitations to all season ticket holder parties and other team parties, a VIP Parking

Pass, and each game's giveaway item, even if they came to the game late.

The team offers a number of "In Game Promotions" that are intriguing to fans. By placing their name on a coupon and dropping it into a bin before each game, the drawn fan will have the opportunity to win a new PT Cruiser by throwing a Frisbee through the open windows at 70 feet. Other drawn fans can win $10,000 by hitting a target on second base with a tennis ball. In the "hit for the cycle" contest at each game a fan's name is drawn at the beginning, and if a RiverHawk player "hits for the cycle" (a single, double, triple and home run) during that game the lucky fan wins a new motorcycle courtesy of a local dealer. In the Denny's Restaurants "Grand Slam Contest," if a RiverHawk player hits a home run with the bases loaded, everyone in attendance can show their ticket stub for the game at area Denny's Restaurants, and receive a free "grand slam breakfast." There are other enticing "In Game Promotions" that keep the fans coming and hoping.

The Rockford RiverHawks are a fine group of young men who enjoy playing professional baseball. They come to Rockford with professional skills that were developed through their college playing experiences, and for many, through their other professional experiences including major league farm teams. They display admirable playing skills and provide the intense baseball action that fans enjoy. They further recognize that they have the opportunity to display their skills because of the fans. They are all very approachable by fans for autographs and baseball conversation.

During the approximately 135 years of professional men's baseball in Rockford the rules of the game may have changed, but the level of play is similar and appreciated by the fans. However, the RiverHawks recognize that they are competing with others for entertainment dollars, and they are committed to carrying the action beyond the playing field. They want to demonstrate that "Its More Than a Game!" and they want to provide "High Flying Family Entertainment."

Fans take in a RiverHawks game at Marinalli Stadium, 2002.

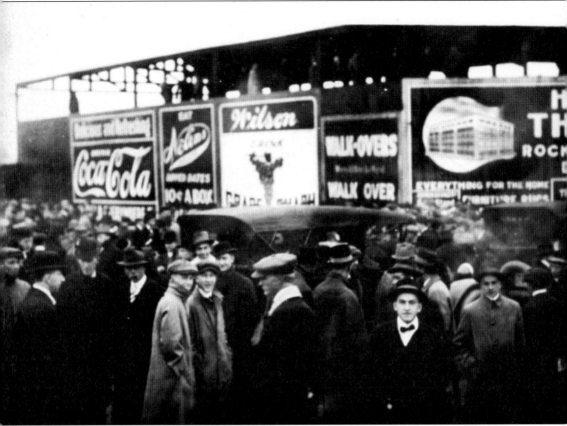

The Rockford Rox, a Class C Cincinnati Reds minor league team, played from 1947 to 1949 in a 15th Avenue stadium near the Rockford Peaches Beyer Stadium. Beyer School is now on that property, according to a Rockford native who both played and attended games there. This is identified as a Rockford baseball stadium by the local merchant advertising billboards; however, local historians are in disagreement as to exactly which stadium it was, and it may not be where the Rockford Rox played (1947-1949). Professional and other baseball in Rockford was played at Fairgrounds Park until the 1890s. At that time a new enclosed ball park was constructed on the West Side and named Camp Grounds Park, near the site of the Civil War Camp Fuller, and the ball park was surrounded by the current N. Main, John, Church and Napoleon Streets. A large amusement park was also located near the baseball stadium. Another ball park was built around 1890 by the "West End Railroad Company," which operated a trolley car company and sponsored a professional team called the Rockford Hustlers. That ball park is reported to have been located near the current West State Street and Johnston Street. It opened on May 27, 1891 with a grandstand holding 1,000 spectators. The trolley company encouraged fans to "ride the trolley" to the ball games.

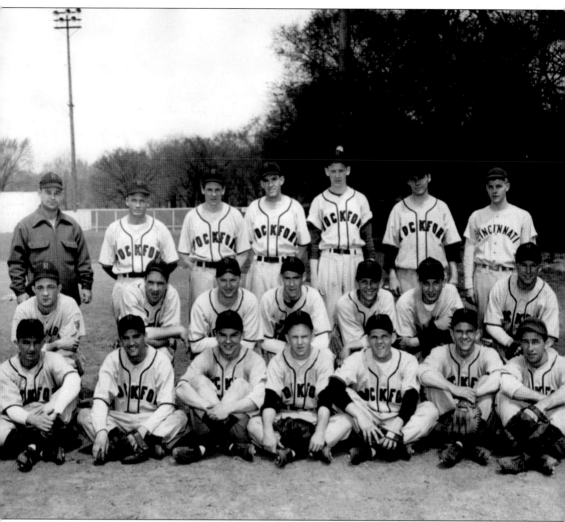

Shortly after World War II (1947) the Cincinnati Reds major league baseball team located their Class C farm team in Rockford. Home games were played at a baseball stadium located next to the football stadium where the Rockford Peaches played on a converted field. The Rox and the Peaches could not share a field for a number of reasons, most important being that the men's baseball playing rules required a much larger playing field. The Peaches played on essentially a softball diamond with shorter base paths and a shorter pitching distance. The Rox played in the Central Association, a league made-up of Illinois, Missouri, and Iowa Class C minor league teams. The Rox finished third in 1947, fifth in 1948, and last in 1949. The Rox did not draw well, and were reportedly more than $35,000 in debt when the Central Association took control of the team, and moved it to another city for the 1950 season.

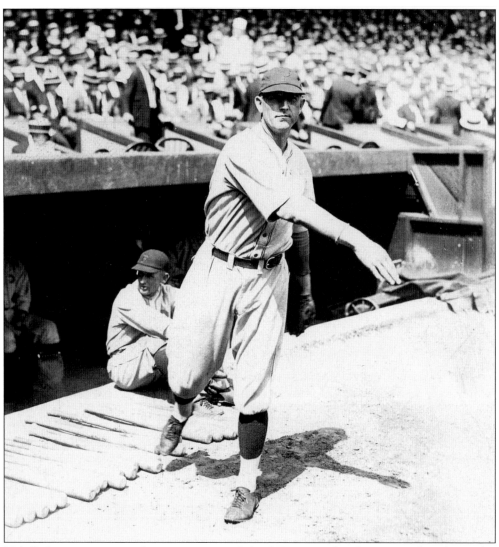

Hal Carlson warming up for a game, one of the 377 games that he appeared in during his fourteen year major league career. Hal Carlson was born in Rockford in 1894. He played for the "Rockford Maroons, [a team] made-up of young men of Swedish-American parentage." Following play with several minor league teams as a pitcher, Hal appeared in the major leagues with the Pittsburgh Pirates (1917-1923), Philadelphia Phillies (1924-1927), and Chicago Cubs (1927-1930). In the 1929 World Series Carlson pitched four innings of relief in two games without a decision. He was cheered in Rockford, his hometown. During the 1930 baseball season Hal rented an apartment in a hotel near Wrigley Field, while his wife and child stayed in their Rockford home. At the end of the sixth week of the season Hal Carlson was enjoying a 4-2 win-loss record and was scheduled to start the game on May 28. He woke-up early that morning after experiencing stomach pains throughout the night, probably from the ulcers that he had problems with before. He summoned the Cubs' doctor, who arrived with Cubs' teammates Riggs Stephenson, Kiki Cuyler, and Cliff Heathcote. Hal died as they were planning to move him to a nearby hospital. The Rockford community was shocked by the news that their hero and "favorite son" had suddenly died after having just reached age 36 eleven days before. (Courtesy of the Rockford Midway Village and Museum Center.)

Hal Carlson—Rockford's favorite son and tragic loss—is pictured later in his career as a Chicago Cub (1927-1930), where he achieved his greatest success, a 30-17 won-loss record. Hal Carlson's personal artifacts are on permanent display at the Swedish Society Erlander Home in Rockford.

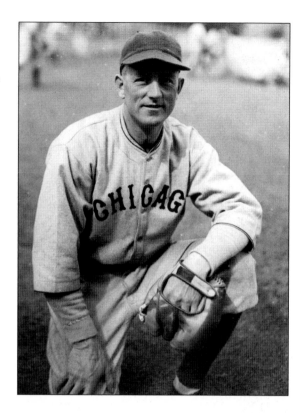

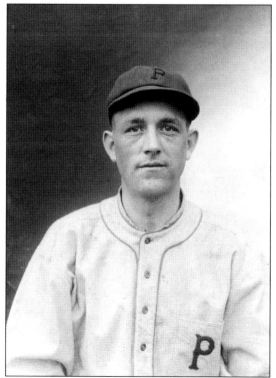

Hal Carlson pictured as a young pitcher with the Pittsburgh Pirates. In 1917, where he started 17 games, finishing 9, Carlson posted a 7-11 won-loss record and a 2.90 ERA. His only winning season with the Pirates was in 1920, when he achieved a 14-13 won-loss record and a 3.36 ERA. Traded to the Philadelphia Phillies in 1924, his best season with them was 1926, when he was 17-12 with a 3.23 ERA (Courtesy of the Rockford Midway Village and Museum Center.)

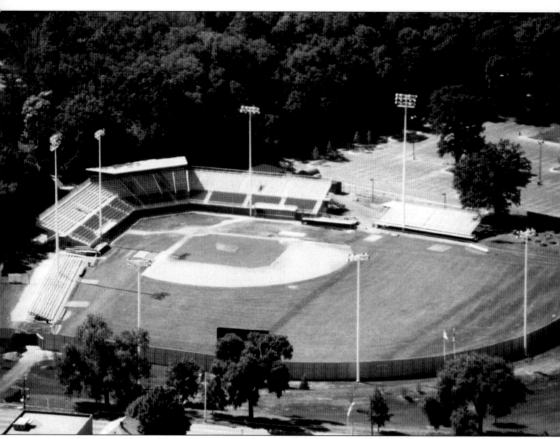

A remodeled Marinelli Field—named for a deceased local amateur player—served as home to four Midwest League (single A) teams over twelve seasons: the Expos (1988-1992), the Royals (1993-1994), the Cubbies (1995-1998), and the Reds in 1999. Though Rockford fielded some competitive teams and produced some top major league talent during this stretch, the lack of stability—four affiliations in just 12 years—as teams were lured to other cities with newer and larger stadiums, did little to establish a local, loyal fan-base. (Courtesy of the Rockford Park District.)

From 1995 through 1998 Rockford was home to the Cubbies, the Class A Midwest League team of the Chicago Cubs. (Courtesy of Rockford Park District.)

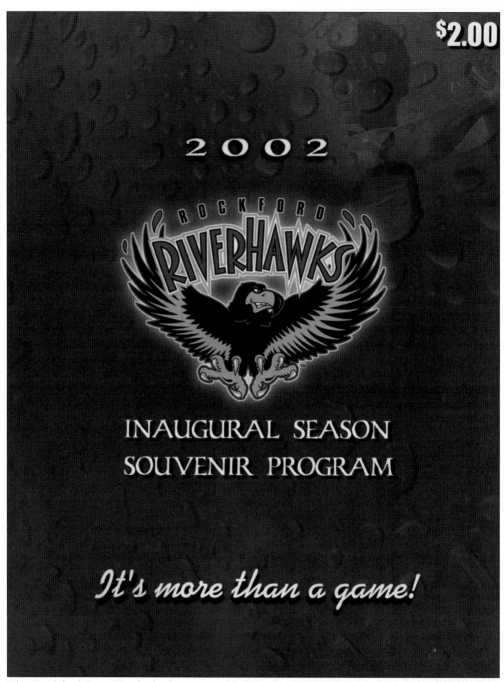

$2.00

2002

ROCKFORD RIVERHAWKS

INAUGURAL SEASON
SOUVENIR PROGRAM

It's more than a game!

The Rockford RiverHawks had a successful first season in 2002, averaging more than 2,100 spectators per game, and making a positive impact upon the city of Rockford. It was evident that the RiverHawks were able to provide the type of professional baseball entertainment that the Rockford area could respond to. The following pictures will illustrate both the high level of play of the Rockford RiverHawks, a professional baseball team, and the manner in which they made attending a professional baseball game a very entertaining experience.

102

Richard Austin, a returning RiverHawk outfielder, prepares to swing at the next pitch. After just five games in 2003, he was batting .412 and looking forward to a great season. (Courtesy of the Rockford RiverHawks.)

Josh Lattimer, a former Southern Illinois University left handed pitcher, showed good promise in 2002. (Courtesy of the Rockford RiverHawks.)

The confrontation between the base runner attempting to score, and the catcher guarding the plate, is arguably the most traumatic play in baseball. The situation provides the most severe legal contact between players. (Courtesy of the Rockford RiverHawks.)

With the catcher completely blocking the plate, and holding the ball in his control, the runner's only chance of scoring is to "slam" into the catcher with enough force to make him drop the ball. The RiverHawk runner, #10, Tony Pigott is back for another season. (Courtesy of the Rockford RiverHawks.)

This RiverHawks third baseman is ready to respond to the action generated by the next pitch. (Courtesy of the Rockford RiverHawks.)

Laying down a perfect bunt to advance the runner or to get on base is one of the fundamental skills employed and taught by the RiverHawk manager and coaches. (Courtesy of the Rockford RiverHawks.)

Louis Carmona turns a successful double play for the RiverHawks. (Courtesy of the Rockford RiverHawks.)

An unidentified RiverHawk gets ahold of one for the fans at Marinelli Field.

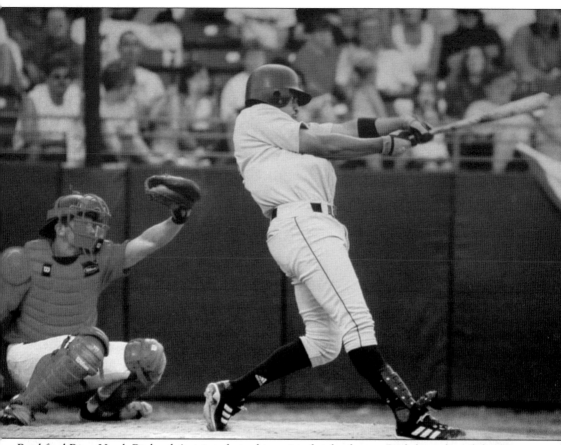

Rockford RiverHawk Richard Austin takes a big swing for the fences. Rich batted a solid .300 while leading the RiverHawks with 11 homers in 2002. He was fifth in the league with an on base percentage of .431.

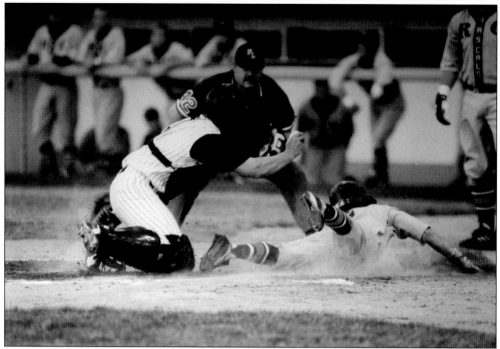

'You're out" yells the umpire after the RiverHawk catcher tags an opponent. (Courtesy of the Rockford RiverHawks.)

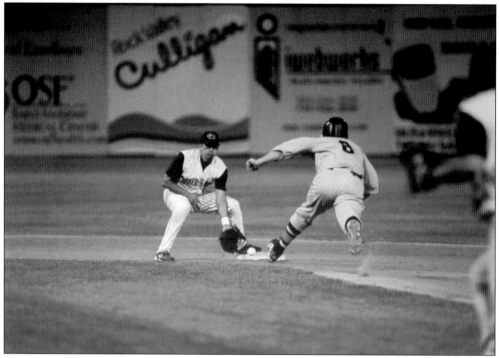

Dramatic playing action with fence advertising as the backdrop. (Courtesy of the Rockford RiverHawks.)

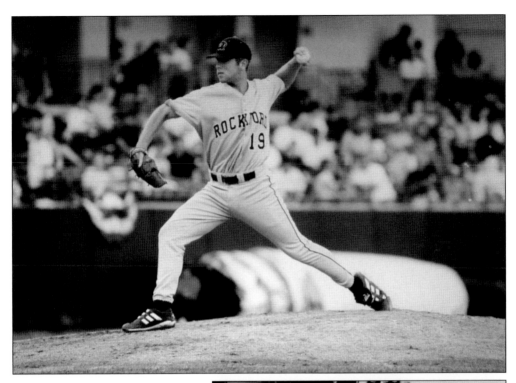

Number 19, left handed pitcher
Ryan Takach, showed good
abilities in 2002.

Jason Shelly, a right handed
pitcher, is shown accepting a
"Player of the Month" award from
General Manager Mike Babcock
during the 2002 season. In 2002
he set the Frontier League all-time
strikeout record at 154. Shelly has
returned for the 2003 season.
(Courtesy of the Rockford
RiverHawks.)

A conference on the mound as Manager Bob Koopmann considers bringing in a relief pitcher. (Courtesy of the Rockford RiverHawks.)

Manager Bob Koopmann brings a wealth of experience to the RiverHawks, having been a pitcher in the Pittsburgh Pirates farm system from 1985-1989. He became the RiverHawks' first manager prior to the 2002 season, and is also head coach for a college team whose season ends just before the RiverHawks "spring training" starts. He has been a college coach since 1990. All three of his coaches are also college graduates with considerable college playing experience, and with extensive college coaching experience. (Courtesy of the Rockford RiverHawks.)

Outfielder Richard Auston is being congratulated by his teammates for one of the 11 home runs that he hit in 2002, while batting .300 in 73 games. He is returning for the 2003 season. (Courtesy of the Rockford RiverHawks.)

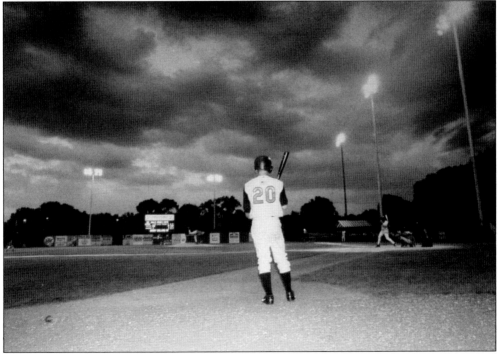

On a warm summer evening in 2002, Justin Williams patiently waits for his turn at bat. (Courtesy of the Rockford RiverHawks.)

It takes more than playing exciting baseball to build the fan base that a professional team needs to survive as a business. Coming to a game must be an enjoyable experience for all fans and every member of every family. In the year 2002 the team motto was "It's more than a game!" That motto was demonstrated throughout the season by the various promotions and other activities that entertained the fans. The season 2003 motto is "High Flying Family Fun," which Rockford area fans responded to by purchasing close to 900 season tickets before play began. On opening night (2003) it was reported that over 3,800 fans purchased tickets for the game. (Courtesy of the Rockford RiverHawks.)

Connecting with the Rockford community is very important to the RiverHawks, who give special attention to fans both young and old, including scheduled "meet the team nights" in local establishments, with autographs encouraged.

Prior to every home game the practice of inviting local groups to sing our National Anthem and honor "the colors" has been very successful. Friends and neighbors come to the game to see and hear the participants, as well as seeing good baseball being played. Many return for future games.

Recording their pitching speed as measured by the radar gun, fans young and old can win game tickets, bats, balls, and other prizes.

On-the-field instructions given by Riverhawk players are offered to young fans on special afternoons and evenings throughout the season.

114

RiverHawk pitcher Justin Rees instructs a young pitcher on the proper "pitching kick."

The RiverHawks players and coaches are available to young fans, both boys and girls, at various times throughout the season, and teach these young fans some of the fine points of the game. Children are awarded with free tickets for joining Rocko's Kid Club, the Reading Club, having School Perfect Attendance, being on the Honor Roll, and a host of other achievements that can also bring rewards.

The "RiverHawk Diamond Dolls" assist at each game by handing out the promotion for that game, spotlighting the "first pitch," carrying out the gimmick activities, and other attractions such as "shooting T shirts" to the fans with a "special slingshot."

"Rocko the Bird" is the RiverHawks "huggable and lovable mascot," a favorite of fans as he wanders around and "intrudes" upon fans in a playful manner. His favorite athletes are "all of the RiverHawks," and his "favorite all time athlete is Larry Bird." His childhood hero was "Big Bird." When invited, Rocko will make community appearances to promote the RiverHawks.

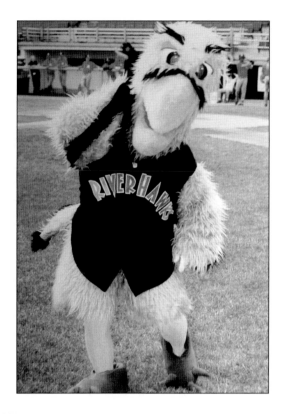

Rockford Mayor Doug Scott is a frequent spectator at RiverHawks games, and is sometimes called upon to throw out the "first pitch," a custom that is usually continued before other games with a celebrity doing the honors, or a fan who was selected from the stands. It is always a fun experience to see how poorly some get the ball to the plate. None of the "first pitch" throwers have been signed by the RiverHawk…yet.

Rockford RiverHawks take batting practice before a big home game at Marinelli Field, hoping to impress major league scouts and begin that long journey to Cooperstown and follow in the footsteps A.G. Spalding set over one hundred years ago.

FIVE

Remembering Rockford's Baseball Heritage

The Rockford Midway Village & Museum Center celebrates Rockford's past and provides a multitude of educational experiences that focus upon the history of Rockford and the Rock River Valley. From May 3rd through October 29, 2003, the Museum Center featured an extensive exhibit titled "Batter Up! Two Centuries of Rockford Baseball." The exhibit featured vintage uniforms, photographs, programs, scorecards, and other memorabilia, in addition to displays about some of Rockford's famous teams, including the Peaches and the Forest City's. It further featured some of Rockford's famous baseball players and baseball events. The author of this book was a consultant on this exhibit.

Midway Marauders Nick Meyer (left), umpire "Honest" Ken Griswold (center) and Bill Rose pose on game day at the Rockford Midway Village and Museum Center in June of 2003.

The striker takes aim at the pitch.

Vintage base ball matches can become quite competitive and full of action—much as it was during Spalding's era.

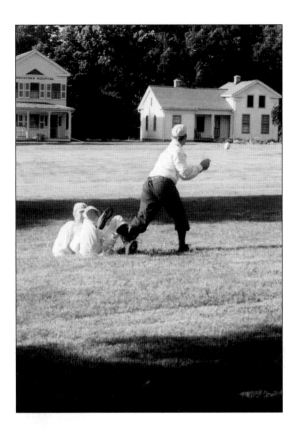

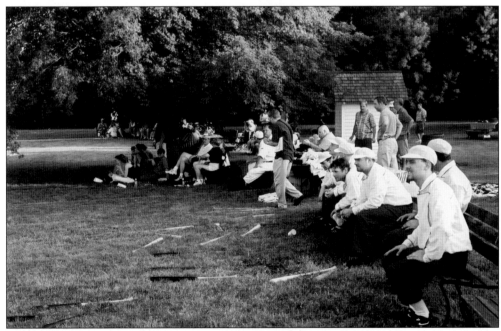

Fellow Marauders cheer on their striker as curious spectators gather down the first base line.

Rockford's Bicentennial Bicycle Path, alongside the Rock River, features a series of three-sided displays celebrating individuals and institutions that played an important part in Rockford's history included are the Forest City Baseball Club (left), which "rose to national prominence on the strength of a pitcher named Albert Goodwill Spalding, a local grocery clerk," and the Rockford Peaches (right), "charter members of the All-American Girls Professional Baseball League and one of only two teams to play in every year of its existence (1943-1954)."

Like mother, like son... John Melin, son of Rockford Peach Berith "Berry" Ahlquist Melin, carried on his mother's tradition by playing 16 seasons of local league softball in and around Rockford. He poses with an AAGPBBL ball and the glove used by Berry as the starting center fielder during the 1943 season.

Rockford Natives Who
Made it to the Show

IT CAN BE DIFFICULT to cite individuals who stand-out among others and be designated as belonging in a "who's who." In this chapter the individuals listed and discussed have been limited to those who played baseball on a major league team, including the National Association, the National League, the American Association, and the American League. These individuals must have been born in Rockford or the Rock River Valley area. An exception is being made for Adrian Anson, because of the magnitude of his performance and the fact that he did play on the Rockford Forest City team when it was a major league team playing in the National Association, and his longtime association with Albert Goodwill Spalding.

ADDY, BOB—*Born in Rochester, NEW YORK, 1845, played for the National Association Rockford Forest City's in 1871, following play with the Rockford Forest City team in the late 1860s. From 1873 to 1875 he played for Boston, Philadelphia, and Hartford in the National Association. Bob appeared in 185 games with a .278 batting average. He died in Pocatello, Idaho, 1910.*

ANSON, ADRIAN CONSTANTINE "CAP"—*The greatest baseball player to have ever played for a Rockford team, Cap was born in Marshalltown, Iowa in 1851. His baseball skills were noticed by Al Spalding when the Rockford Forest City team played there in 1869. At that time Spalding and other Forest City players tried to induce Anson to come to Rockford and play with them. Anson's sense of personal loyalty to his hometown prevented him from coming until 1871, when the Rockford team was professional, and a part of the first major league, the National Association. Although the Forest City team without Spalding was a losing team, Anson distinguished himself and was invited to play for the Philadelphia Athletics, where he batted .352 over four seasons (1872-1875), playing most positions except pitcher, and managing in 1875. When Spalding and William Hulbert created the National League in 1876, Anson was the player that they most wanted for their Chicago White Stockings team. They named him the team's "Captain," and he became "Cap," the name that he most liked in following years, even during the 20 years that he was the team's manager. He was arguably the greatest baseball player of the 19th century, playing professionally for 27 years (1871-1897). Playing and managing for the Chicago White Stockings (1876-1897) he played every position including pitcher when needed. In a record setting 2,276 National League games he had a lifetime batting average of .333. As a manager (1872-1898) he had a 1,297 wins to 957 losses, with five first place finishes, four second, two third, and was considered to be the foremost strategist of his time. Always in command of himself, as well as his team, he demonstrated integrity, dignity and sobriety, and never "letting down his guard," as an example to others.*

BARKER, AL—*Born in Rockford in 1839, he played for the National Association Rockford Forest City's in 1871, appearing in one game. He had been a regular member of Rockford Forest City teams in the late 1860s with Spalding. Barker died in Rockford in 1912.*

BARNES, ROSS—Born in Mt. Morris, 1850, later moved to Rockford where his family established a manufacturing plant that still exists. Barnes played on the Forest City teams with Spalding and went to the Boston Red Stockings with his friend in 1871, when the National Association was formed. With Boston he played until 1875, appearing in 266 games, mostly at second base. His batting average for those five seasons was .379, hitting .404 in 1872, and .402 in 1873. When the National League started play in 1876, Spalding induced Ross to join him and the Chicago White Stockings. In this new professional league consisting of the best baseball players in the country, Ross Barnes led the league in hits (138), runs scored (126), bases on balls (20), and both batting average (.404) and slugging average (.556). During that first year of the National League, Ross Barnes was clearly the best hitter, Al Spalding was clearly the best pitcher (46-12 / ERA 1.75) and their team, the Chicago White Stockings, was clearly the best team (52-14). In 1877 Barnes slipped to a .272 batting average for Chicago. In 1879 Barnes played in 77 games for Cincinnati, batting .266. In 1881 he appeared in 69 games for Boston, batting .271. His lifetime batting average was .313. Roscoe "Ross" Barnes has from time-to-time been given serious consideration for election to the National Baseball Hall of Fame. He died in 1915, and is buried in the Barnes Family plot in Greenwood Cemetery, Rockford.

BIRD, GEORGE—Born in Stillman Valley, Illinois in 1850, George had been a member of the Rockford Forest City team in the late 1860s and joined the professional National Association Rockford Forest City's team in 1871. He played in all 25 games that year, batting .214. He died in Rockford in 1940, reaching age 90.

CARLSON, HAL—Born in Rockford in 1894, Hal died tragically during his fourteenth major league season, in May of 1930 (see page 98). He played for the Pirates, Phillies and Cubs with a career won-loss record of 114-120 and a 3.97 ERA. Hal won a career high 17 games in 1927 and went 64-48 from 1925 until his death at the age of 38. He could also hit, delivering a pinch-hit home run for the Phillies during the 1925 season.

CHARBONEAU, JOE—Was born in Belvidere, Illinois, in June 1955. He reached the major leagues with the Cleveland Indians in 1980, where in 131 games he batted .289, hit 23 home runs, and drove in 87 runs. He received the American League Rookie of the Year award for his performance. The next season he appeared in only 48 games, batting .210. The following season, 1982, he appeared in only 22 games for the Indians, with a .214 batting average. He didn't have another major league season. Joe is currently an executive with the Washington, PA team in the Frontier League, the same league that the Rockford RiverHawks play in.

CONE, FRED—Born in Rockford, 1848, Fred had been a teammate of Spalding on the Rockford Forest City teams in the late 1860s and followed him to Boston when the National Association began play. In 1871 he appeared in 18 games, batting .235. He died in 1909 in Chicago.

HILLEBRAND, HOMER—Born in Freeport, IL, 1879, he appeared in three major league seasons (1905-1908), all with the Pittsburgh Pirates. Primarily a pitcher, during his first season, 1905, Homer appeared in 10 games, starting all of them, and completing six. His 1905 won-loss record was 5-2, with a 2.85 ERA. In 1906 he started five games, completing four with a 3-2 record and a 2.21 ERA. He apparently was in the minor leagues in 1907, returning in 1908 to Pittsburgh, when he pitched in one game with no decision. A versatile player in 1905, in addition to pitching he appeared in 16 games as a first baseman, seven as an outfielder, and three as a catcher. Homer's overall batting average in the major leagues, in 47 games, was .237. His 1906 and 1908 appearances were all as a pitcher. Homer died in 1974 in Elsinore, CA, reaching the age of 94.

JORGENS, ART—A brother of Orville Jorgens, Art was born in Norway in 1905. It can be assumed that he was living in Rockford, when his brother Orville, also a major league player, was born in 1908. Art was a catcher for the New York Yankees for 11 seasons (1929-1939), appearing in 306 games, including 17 pinch-hit appearances. He recorded a career .238 batting average. Although the Yankees were in the World Series many of the years that Art was a member of the team, he did not have a world series appearance. Art died in 1980 in Wilmette, IL.

JORGENS, ORVILLE—(brother of Art Jorgens) was born in Rockford, 1908. A pitcher, he played three seasons in the major leagues for the Philadelphia Phillies (1935-1937), compiling a 21-27 W-L record, with a 4.70 ERA. Appearing in 144 games he started 56 and completed 11. In relief pitching he won 6 and lost 4, recording 5 saves.

LAMONT, GENE—Was born on Christmas Day in Rockford, 1946, in Rockford. He graduated from Hiawatha High School in Kirkland, where he starred in football, basketball and baseball. A catcher, he was signed by the Detroit Tigers upon high school graduation. He later attended both Northern Illinois University and Western Illinois University during off-seasons. Following several minor league seasons Gene made his first major league appearance with the Tigers

in 1970, and was with them during parts of the 1971-1975 seasons, appearing in 87 major league games and posting a .233 career batting average. He then coached and managed in the minor leagues before becoming a third base coach with the Pittsburgh Pirates from 1986-1991, and again in 1996. Lamont was a major league manager with the Chicago White Sox, 1992-1995, and led the Sox to first place finishes in both 1993 and 1994. From 1997-2000 Lamont managed the Pittsburgh Pirates. He is currently the third base coach for the Houston Astros.

MEYERS, RODNEY—Was born in Rockford in 1969. A Rockford East High School graduate, Rodney was all-conference in both football and baseball, and also played basketball. He played baseball for the University of Wisconsin for three years before signing with the Kansas City Royals. In 1993 he played minor league ball in Rockford for the Royals Class A Midwest League farm team. That season he posted a 7-3 win-loss record and a 1.79 ERA. He started 12 games and completed five of them. In 1995 he was acquired by the Chicago Cubs and made it to the majors with the Cubs in 1996. Rodney spent parts of four seasons in the major leagues with the Cubs (1996- 1999), and parts of three seasons with the San Diego Padres (2000-2002). During his seven year major league career Meyers has appeared in 162 games (1996-2002) and has posted a 7-5 win-loss record with 5.08 ERA. Acquired by the Los Angeles Dodgers in December 2002, he is currently pitching for their AAA team in Las Vegas, and is awaiting a call back to the major leagues.

NICOL, HUGH—Born in Scotland, Rockford history cites him as having local ties both as a player/manager and as a resident. Nicol appeared in 1881 and 1882 with the Chicago White Stockings, having been signed by Albert Spalding. From 1883-1889 he played for St. Louis in the American Association (with Charles Comiskey), and in 1890 with Cincinnati in the National League. In 1891 Nicol managed a Rockford minor league team that was pictured earlier in this book, and apparently managed other minor league teams. In 1896 he was living in Rockford and together with A.G. Spalding organized the "Harry Wright Day" festivities in Rockford. In 1897 he managed the St.Louis Cardinals. He died in La fayette, IN 1921.

POTTER, NELSON—Was born in Mount Morris, IL (near Rockford) in 1911. A pitcher, his first major league appearance was with the St. Louis Cardinals in 1936. He played for the Philadelphia Athletics 1938-1941, and was traded to the Boston Red Sox during the 1941 season. In 1943 he was acquired by the St. Louis Browns, remaining with them into the 1948 season when he was acquired first by the Philadelphia Athletics and then the Boston Braves who were in route to the National League pennant. Potter's career ended with the Braves in 1949. Potter appeared in two world series. In 1944 he led the Browns to their only American League Pennant, when he posted a 19-7 win- loss record and a 2.83 ERA, as he started 29 games and completed 16. In 1948 he appeared in 28 games, 18 for the Boston Braves, helping them to win the National League Pennant. His overall major league record during his 12 years was 92 wins and 97 losses, and a 3.99 ERA. He started 177 games and completed 89 of them. In the 1944 and 1948 World Series he appeared in four games, starting three of those games, and earning a world series ERA of 3.60. He recently died in Mount Morris.

RUDOLPH, KEN—Was born in Rockford in 1946. Ken played in 328 major league games, primarily as a catcher. His rookie year he also played three games in the outfield. He was with the Chicago Cubs from 1969-1973, the San Francisco Giants in 1974, and the St. Louis Cardinals 1975 & 1976. In 1977 he played for both San Francisco and Baltimore. Rudolph appeared in 328 major league games, posting a 213 batting average.

SCHULTE, FRED—Was born in Belvidere, IL in 1901, and died there in 1983. His 95-year-old wife still lives there (2003). Schulte's major league career began with the St. Louis Browns in 1927 and continued with the Browns through 1932, when he was acquired by the Washington Senators (1933-1935). In 1936 and 1937 Fred played for the Pittsburgh Pirates. During his 11 years in the major leagues, Fred appeared in 1,178 games as an outfielder. His career batting was .292. He appeared in the 1933 world series with Washington, batting .333 in the five games with 21 at bats. His home run won a world series games for the Senators. Fred retired to Belvidere and operated a bowling alley. He also scouted the Rockford area for several major league teams, and umpired a number of games each season. Among the games that he umpired were those of the Rockford Peaches.

ALBERT GOODWILL SPALDING—Born in Byron, Illinois in 1850, it was in Rockford where he developed his roots and received his start, both in baseball and in business. He maintained his contacts in Rockford, even though he was living in other places. His mother, Harriett, lived in Rockford, with Albert's sister and her husband (and a business partner of Albert), until the time of her death in the 1880s.Al Spalding often returned to Rockford when he was living in Chicago, and later when he was living in the East and in California. In 1896 Spalding chaired, together with Hugh Nicol, a celebration in Rockford to honor his friend and mentor, Harry Wright. He always maintained contact with his former teammates and friends, most of whom participated when Wright was honored in Rockford.

Albert Spalding's contributions to baseball and sports equipment were so many, and touched all facets of all games, that he can only be described as being a legend, a legend that Rockford can be very proud of.

STIRES, GARRET "GAT"—*Was born in upstate New York, but came to Byron, IL with his parents, when a child. There he was a boyhood friend of Albert Spalding, a friendship that was maintained until Spalding's death in 1915. An outstanding local Byron ball player (note previous story in this book), Stires was invited to come to Rockford and play on the Forest City team in the late 1860s, which he did, remaining with them through the 1871 season when they were a part of the National Association. Stires played all 25 games for the 1871 Forest City's as an outfielder. When the season was over so was his major league career. In 1874, when helping to plan the trip of ball players to Europe, Spalding invited Stires to join the team that he was putting together. A tattered post card in the A.G. Spalding collection that is housed in the Byron Public Library mentions "Gat's" decline of the invitation because his "girl friend" was opposed. It further indicates that may have been the reason for their break-up. Stires remained a bachelor for the rest of his life. He passed away in 1933 and is buried in the Byron Cemetery.*

SULLIVAN, HARRY—*Was born in Rockford in 1888, and died in Rockford in 1919. In 1909 he pitched in two games for the St. Louis Cardinals, starting one of them. He had no won-loss record, but posted a 36.00 ERA.*

SWARTWOOD, ED—*Was born in Rockford in 1859. From 1881-1892 he spent nine years in the major leagues with Buffalo, Pittsburgh, Brooklyn, Toledo, and finishing his career with Pittsburgh in 1892. Appearing in 724 games he posted a .299 batting average. An outfielder, he also played other positions, even pitching in two games with no record of decisions. He died in Pittsburgh in 1924.*

SWINDELL, CHARLIE—*Was born in Rockford in 1877. He caught three games for the St. Louis Cardinals in 1904. At bat eight times, he had one hit for a .125 batting average. He died in 1940 in Portland, Oregon.*

TIPPLE, DAN—*Was born in Rockford in 1890 and pitched in three games for the New York Yankees in 1915. He started two of those games and completed both. His won-loss record was 1-1 and his ERA was 2.84. Those were his only major league appearances. He died in Omaha, Nebraska in 1960.*

Nelson Potter from Mount Morris, Illinois, pictured here before a 1944 World Series start, is representative of a long term major league baseball player who was never a star, but nevertheless had longevity. Potter played on five different teams during 12 seasons in the major leagues. His win-loss record was 92-97 and his career ERA was 3.99. He played in the 1944 World Series and the 1948 World Series, starting three games and relieving in another.

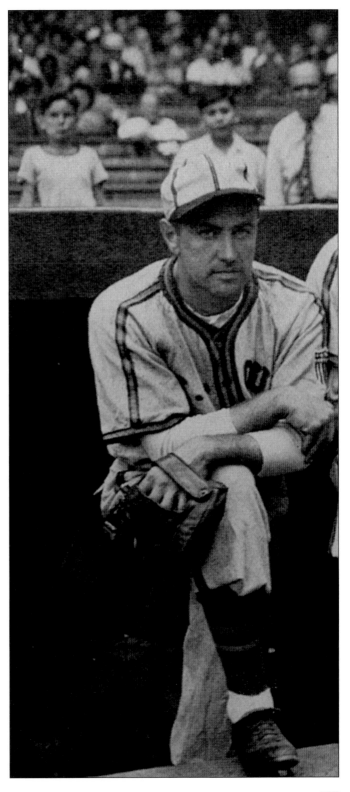

EPILOGUE

WHAT HAPPENS WITH OLDER "die hard" baseball players in Rockford? Where do they go and where do they play after their "hard ball" skills are diminished, or there are fewer like them who can still play? A few have turned to fast pitch softball, but most take-up slow pitch softball, playing on sponsored and organized teams, with regular weekly schedules, and often weekend tournaments. Rockford has many hundreds of slow pitch softball players, both men and women, who compete both for the fun of the game, and the socializing that becomes a part of the experience. However, even these players have grown older.

In recent years the Rockford Park District has helped to form and operate an "over 50 league" for those die hards who want to continue playing slow pitch softball. A player in that league must be 50 years of age or older, and organizers have found that of the 71 men who are currently competing on five teams, about one-third of them are over age 60, and three are over age 70. The league plays a 16 week schedule, with all games on Wednesday evenings. With about 14 players on each team, league rules require that each player must both bat and field in each half of the innings. Free substitution is allowed, meaning that players who were removed from a game can re-enter as needed. Players can even take a game or two off for planned family vacations. The "over 50 league" has grown more popular each season.

Yes, baseball, and its rich history traditions is alive and well in Rockford, Illinois!